RIVER DOVE

JAYNE DARBYSHIRE

AMBERLEY

To Peter, Alex, Emily and Katie
with thanks for their company, patience and support

PISCATOR: ... and now, Sir, what think you of our river Dove?
VIATOR: I think it to be the best trout-river in England; and am so far
in love with it, that if it were mine, and that I could keep it to myself, I
would not exchange that water for all the land it runs over.
(Izaak Walton and Charles Cotton, *The Compleat Angler*, 1676)[1]

'Izaak Walton and his scholar' – a woodcut by American illustrator
Louis Rhead (1857–1926).

First published 2012

Amberley Publishing
The Hill, Stroud
Gloucestershire, GL5 4EP

www.amberleybooks.com

British Library Cataloguing in Publication Data.
A catalogue record for this book is available from the British Library.

ISBN 978-1-4456-0269-1

Typesetting and Origination by Amberley Publishing.
Printed in Great Britain.

Contents

Foreword

The River Dove was first famous as a trout stream. It was immortalised by Izaak Walton in his book *The Compleat Angler, or The Contemplative Man's Recreation.*[1] It is far more than just a fishing book, and the banter between the characters Piscator and Viator gives a fascinating insight into seventeenth-century rural England. Walton's great friend and fishing companion Charles Cotton, who lived close to the Dove at Beresford Hall, wrote a second part to the fifth edition. No English-language book, other than the Bible and Book of Common Prayer, has been reprinted more times.

But although Walton and Cotton gave the Dove its initial claim to fame, it was the Romantic Movement in the eighteenth century that led to a massive surge in Dovedale's popularity. Over millions of years the waters have carved out the steep and craggy gorges in the outstandingly beautiful dales of the Dove into interesting shaped hills, fantastical rock formations and amazing caves. This hitherto unappreciated scenery began to generate awesome appeal in the Romantic period, when visitors came to seek out presentiments of awe, grandeur and the sublime.

Many visitors stayed in Ashbourne, just a short ride or drive out from the increasingly popular Dovedale. They brought prosperity, status and the latest fashions to what was formerly a little-known rural town. Massively popular then since the eighteenth century, Dovedale is still one of the most visited natural tourist sites in Britain. It contains the most walked along 2½ miles in the Peak District. Over a million visitors a year cross the stepping stones beneath the reef knoll Thorpe Cloud to admire the steep wooded sides of the valleys and white rocks carved into towers, caves and spires.

But there is far more to the Dove than just Dovedale. Round every bend of every stretch of this river there are fascinating pieces of evidence from days gone by. Packhorse bridges along medieval trails pepper the upper part of the Dove, where teams of up to forty horses once carried heavily laden panniers of minerals and cloths. For the more energetic, reef limestone hills rise steeply from the river banks to form some of the few real peaks in the Peak District, providing excellent vantage points, from which the course of the river can be viewed .

The fantastically carved limestone cliffs of her much-visited mid-region were painted by early landscape artists. Spectacular caves along her banks were used as shelters as far back as the last ice age. The waters of her lower regions flow over the red sandstone of southern Derbyshire where both villages and landscape undergo a noticeable change. Imposing manor houses abound, with grounds that sweep down to

her banks – once the property of ruling local gentry whose presence remains in often elaborate church tombs. Their once extensive parklands provide flatter expanses of lush grazing, made fertile by the waters of the Dove as she winds beneath the imposing remains of Tutbury Castle to her eventual confluence with the Trent.

Ancient customs and peculiar traditions remain rooted in the villages and small towns that flank her course. Then there are the old tales. Was Chattering Charteris, of The Headless Woman pub in Earl Sterndale, really so bad that she drove her husband to commit his terrible deed? Did Bonnie Prince Charlie's rampaging troops deserve their gruesome fate on Mayfield's Hanging Bridge? And how did 300,000 silver coins come to lie in the bed of the lower regions of the River Dove for 500 years before their discovery in 1831?

But the aim of this book is not to find answers. It is simply to allow you to submerge yourself, whether on foot, bicycle, in a car or from the comfort of your own armchair, in the vast wealth of fascinating history and folklore, as well as the outstanding beauty that lies along the banks and villages of the entire length of the Dove.

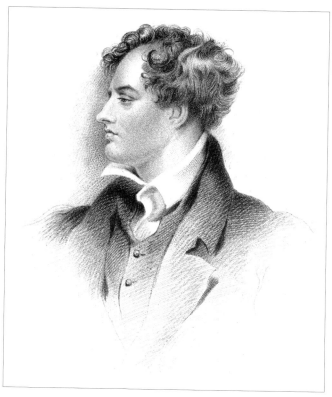

'Was you ever in Dovedale? I can assure you there are things in Derbyshire as noble as Greece or Switzerland.'[2] The Romantic poet Lord Byron (1788–1824) helped to put Dovedale firmly on the tourist map. (NTGM009329. Courtesy of Nottingham City Council and www.picturethepast.org.uk)

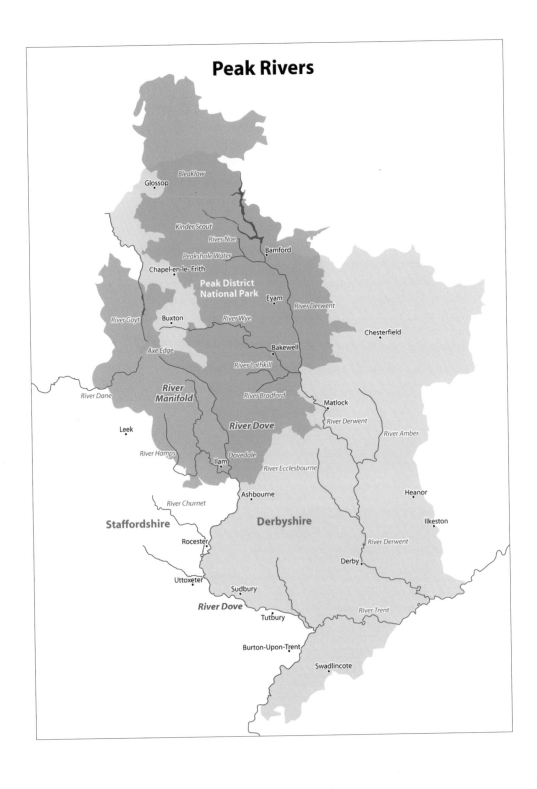

Peak Rivers

Bleaklow

Glossop

Kinder Scout

River Noe

Peakshole Water

Bamford

Chapel-en-le-Frith

Peak District National Park

Eyam

River Derwent

River Goyt

Buxton

River Wye

Chesterfield

Axe Edge

Bakewell

River Lathkill

River Manifold

River Dane

River Bradford

Matlock

River Dove

River Derwent

Leek

River Amber

River Hamps

Dovedale

Ilam

River Ecclesbourne

River Churnet

Ashbourne

Heanor

Staffordshire

Derbyshire

Ilkeston

Rocester

River Derwent

Derby

Uttoxeter

Sudbury

River Dove

Tutbury

River Trent

Burton-Upon-Trent

Swadlincote

Chapter 1
Peak Rivers

Derbyshire's rivers flow roughly from north to south. Just west of Buxton lie the bleak gritstone moorlands of Axe Edge, where the snow lingers longer than in any other part of the Peak District. Receiving a rainfall of around 130 cm a year, this area forms the watershed which gives rise to many rivers, including the Dove, Manifold, Wye, Goyt and Dane.

Derbyshire's biggest river, the Derwent, rises on the eastern flank of Bleaklow in the Dark Peak, 27 km away. At nearly 610 metres (2,000 feet) above sea level, this largely peat-covered, usually boggy, gritstone moorland lies just north of the highest peak in the Peak District, Kinder Scout. Streams running down from Kinder Scout give rise to

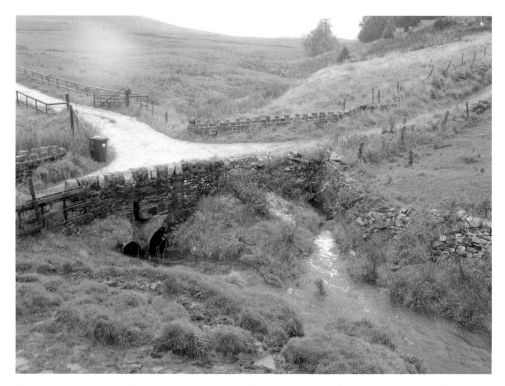

The Dove at Dove Head, close to its origin on the gritstone moorland of Axe Edge (behind).

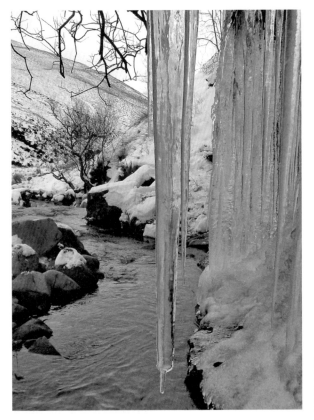

Streams running down from Kinder Scout eventually flow into Derbyshire's largest river, the Derwent.

the River Noe, which, joined by its main tributary Peakshole Water (whose source lies in the depths of Peak Cavern), flows 12 km down the length of the Hope Valley before joining the Derwent, just south of Bamford.

But this craggy landscape of the rivers' gritstone origins does not last. The gritstone of the Dark Peak is in the shape of a horseshoe, with a very different landscape within. After passing through the dramatic moorland and breathtaking landscapes of the gritstone, the rivers flow on through softer limestone-based countryside laced with dry-stone walls enclosing emerald pastures. The pastoral summits and slopes of the limestone White (or Low) Peak form the southern part of the Peak District National Park, where rivers galore wend their way through the magnificent scenic valleys of the Derbyshire Dales.

Having descended through dramatic moorland and breathtaking landscapes, the rivers now leave Britain's first National Park, winding down through gentler and less exciting countryside. They cut through younger red sandstone, used to build the red-brick villages that pepper their banks, some dating back to Anglo-Saxon times. Increasingly they flow under massive concrete bridges carrying huge volumes of A-road traffic, a far cry from the single-slab stones and narrow packhorse bridges of their northern source. All Derbyshire rivers finally join up via the Derwent and the Dove with the Trent. From here, their waters eventually reach the North Sea via the Humber Estuary.

Above, left and right: The White Peak limestone is full of the fossilised remains of coral and other sea creatures from the tropical lagoons, such as these crinoids embedded in the steps at Lovers' Leap along Dovedale.

The Origins of the Rivers

Both Dark and White Peak have their origins around 350 million years ago, when the whole of what has since become the Peak District was submerged under a shallow tropical sea made up of deep lagoons fringed by coral reefs. The limestone which forms what is now the Dove Valley contains the fossilised remains of this coral and other sea creatures that lived within the tropical lagoons.

The Peak District subsequently became part of a huge river delta. Vast quantities of sand and mud washed down the delta, to form the gritstone and shale rocks that comprise Axe Edge, Bleaklow and Kinder Scout. The rocks were pushed upwards by movements in the Earth's crust and rivers formed, which flowed down from the hills.

Gradually, due to natural erosion, layers of gritstone and shale peeled away to leave the limestone dome exposed. As each of the subsequent ice ages came to an end (during the last 2 million years), huge volumes of melted water from shrinking glaciers and rock debris plunged through the valley, cutting through the layers of limestone as easily as a knife through butter. Over millions of years the waters have continued carving their way to create the steep and craggy gorges of Derbyshire's rivers and dales.

The effect of wind and weather over the centuries has had a dramatic effect on the landscape. Some of the limestone formed very hard reefs, similar to those found around tropical islands. This 'reef limestone' has been left standing, towering as fascinatingly shaped hills and peaks (known as reef knolls) above the less-resistant rocks that have been worn away. Many of these rise steeply from the river banks.

This limestone, containing fossilised skeletons of sea creatures, is a heavily jointed rock that can be dissolved by rainwater. This means that some of the White Peak dales are now dry or only occasionally have a river flowing through them, as the water dives underground through sinkholes known as swallet, swallow or shake holes.

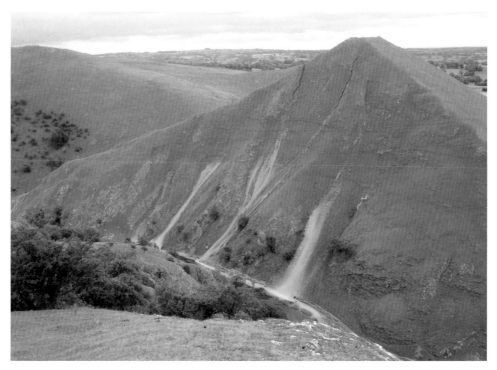

Reef knolls tower with sheer and fluted sides to form the magnificent cockscomb ridges of Chrome and Parkhouse hills along the upper part of the Dove, and the conical Thorpe Cloud above Dovedale (pictured).

By the time it reaches Weag's Bridge, the riverbed of the River Manifold runs completely dry in the summer months.

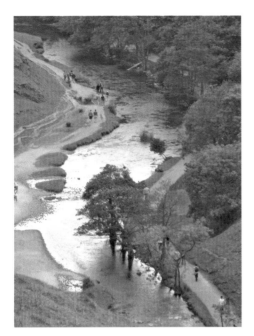 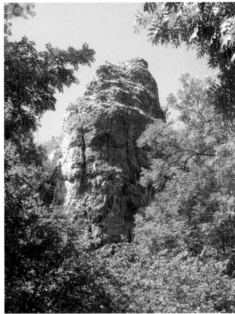

Above, left and right: The Dove, flanked in Dovedale by its astonishing limestone pinnacles, flows throughout all seasons.

Yet despite the similarity of their origins, each of the rivers is distinctive – from the largest, the Derwent (which, at some 50 miles or so in length, is the longest) to the Lathkill which is a mere 6½ miles before it joins the Wye (one of the major tributaries of the Derwent), and is therefore one of the smallest. Each has their particular characteristics, favourite places to visit along their banks, historical uses, and associated tales.

Man and the Peak Rivers

The rivers that rise in the Peak are small and swift. Even the biggest, the Derwent, is not suitable for anything bigger than a rowing boat until it gets almost as far as Derby. Yet water has always been one of the Peak's most important resources.

Many of the villages and small towns which pepper the banks of Derbyshire's rivers have evidence of settlements that were already firmly established before the arrival of William the Conqueror in 1066. Anglo-Saxon communities probably earned their living mainly by agriculture, growing flax by the River Dove and using her waters for many other things, including as an early source of power.

Water Power
William the Conqueror's Domesday Book, completed in 1086, includes a precise count of England's water-powered corn mills. It lists no less than seventy-two in Derbyshire. They used the turning force produced by the running water to turn a paddle wheel,

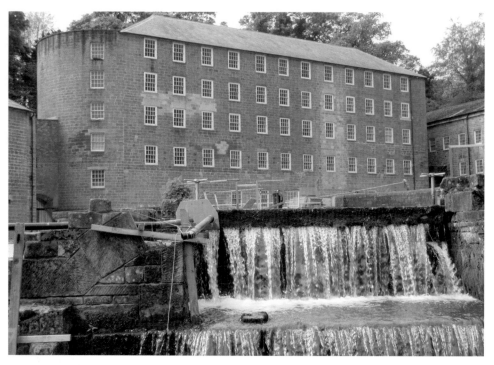

Arkwright used the Derwent to power his first water-powered cotton mill here in Cromford.

Litton Mill, also on the Wye and (like Cressbrook) now transformed into immaculate residential units, became notorious for the appalling way it treated its young labour force.

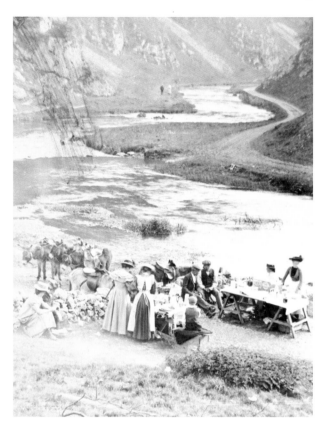

This photograph (1906–16) shows tourists being offered refreshments and donkey rides from the stepping stones, at the southern entrance to Dovedale. (DCHQ004381. Courtesy of Derbyshire Local Studies Library and www.picturethepast.org.uk)

which was attached to a shaft, attached in turn to the centre of the millstone or runner stone which ground against a stationary 'bed' (a stone of similar size and shape). Although a great advance on the age-old method of hand grinding, they were dependent on the volume and flow of water available, meaning the speed of the stone's rotation was variable and the optimum grinding speed couldn't always be maintained.

Over the centuries small water-powered mills were also used for other purposes in Derbyshire, such as crushing mineral ores, pulping rags for paper and even grinding and polishing Ashford's Black Marble.

The Industrial Revolution

From the late eighteenth century, the mills of the Industrial Revolution used water power on a much greater scale. It was the power of the Derwent and its tributaries that first brought Richard Arkwright to Cromford in Derbyshire. Here he built his first water-powered cotton mill, which transformed textile manufacture from a cottage to a factory industry.

More cotton mills followed on the Derwent, the Wye and even on the Dove at Rocester. The village of Cressbrook, built beside the Wye, was entirely a product of the Industrial Revolution, built for the management and workforce of William Newton's Cressbrook Mill, which began production in 1783.

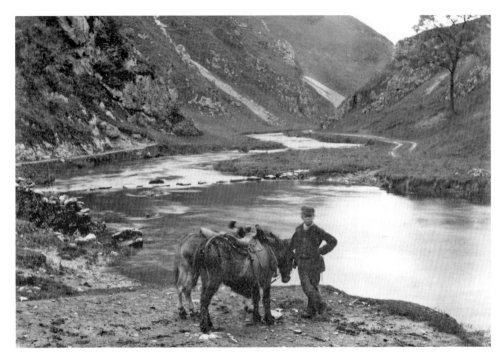

'Donkey Billy' (1890–1950) gave rides on his donkeys down Dovedale to a certain stone. Although he never went with them, they always turned round at that point and came back again. People tried to make them go further, but they never would. (DCBM100728. Courtesy of Buxton Museum and Art Gallery and www.picturethepast.org.uk)

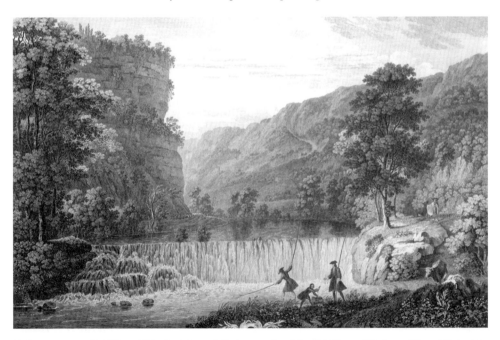

'A Prospect on the River Wie, in Monsal Dale, 2 miles North-West of Bakewell', published in 1743, was one of eight views of the rivers and dales of Derbyshire which Thomas Smith was commissioned to produce. (DMAG300202. Courtesy of Derby Museum and Art Gallery and www.picturethepast.org.uk)

The Tourists

The Romantic Movement in the eighteenth century saw a massive surge in the rivers and dales' popularity. A newly developed 'passion for the picturesque' led members of the aristocracy, gentry and professional classes to seek beauty, initially in the Alps and Apennines, as part of their traditional Grand Tour. But when the Napoleonic Wars put the destinations of France and Italy, Germany and Vienna out of the question, many began to restrict their travelling to places closer to home, where they could experience equal presentiments of awe. Dovedale in particular, with its proximity to the easily accessible and increasingly fashionable town of Ashbourne, became a popular resort.

With improvement in road transport and the arrival of the railways making travel easier, the dales' popularity with visitors expanded as it began to embrace not only the gentry but all social classes. Enterprising local people took full advantage of this influx of visitors to their doorstep.

The Landscape Artists

The 'passion for the picturesque' also lay behind the development of landscape watercolour painting. One of the very earliest landscape artists was Thomas Smith (1720–1767). In 1743 he received a subscription for 'eight of the most extraordinary Natural Prospects in the Mountainous Part of Derbyshire and Staffordshire, commonly called the peak'. These resulted in some of the earliest published views of the rivers and dales of Derbyshire and the Staffordshire border.

Originally eight but followed quickly by more, Smith's views along the rivers and dales were made into prints which the traveller could buy cheaply and take home, much as picture postcards are bought today. His work and that of other artists did much to advertise the Peak District at that time.

The Railways

When the railways arrived in the Peak District they carried millworkers and tourists alike, as well as local farm produce, and caused a major impact on the Peak land and riverscape. But not everybody welcomed them. John Ruskin[3] was outraged when the now famous viaduct at Monsal Head was built to carry the Midland Railway line over the River Wye in 1866.

Today the railways, like the mills, are mostly gone. Some mills have been converted to new purposes, such as shopping centres or cafés to serve the still thriving tourist industry, while the old railway lines (including the one that carried trains over the Monsal Head Viaduct) have also been converted to cycle trails and footpaths.

Uses of the Rivers Today

As Sources of Drinking Water

In the Upper Derwent Valley the Derwent flows into three great reservoirs, Howden, Derwent and Ladybower – built in the early twentieth century to satisfy the growing demand for water from surrounding cities. At just over 3 miles long, Ladybower reservoir was the largest reservoir in Britain at the time of its building. The creation

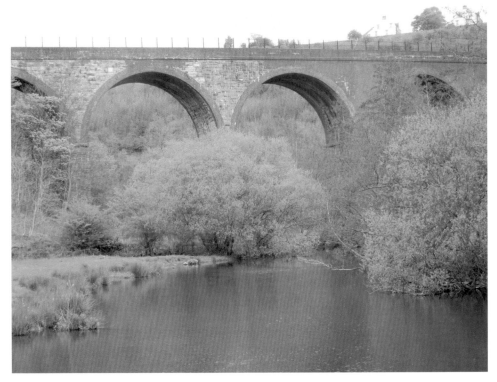

The old railway cuttings at Monsal Head are now of geological significance and designated Sites of Special Scientific Interest. The viaduct itself is listed as being of architectural and historical interest.

of these bodies of water resulted in the 'drowning' of beautiful valleys and the historic villages of Derwent and Ashopston, amid much controversy.

Further down the Derwent Valley, south of Matlock, Carsington Water has become a very popular visitor attraction since the reservoir was opened by the Queen in May 1992. The reservoir is part of a 'water compensation' scheme. Water is pumped here from the River Derwent at times of high rainfall, stored in the reservoir and returned to the Derwent when the river level would otherwise be too low to allow water extraction for treatment (and drinking) further downstream.

As Fishing Streams

The historic home of fly fishing (since it was made famous as an angler's paradise by Izaak Walton and Charles Cotton in the seventeenth century), the Dove is still a fisherman's river. The river is particularly famous for the legendary quality of its barbel, chub, grayling and trout, and the key to a good day's fishing on the Dove, the Burton Mutual Angling Society advises us on their website, is 'to be in the right place at the right time'. But sometimes, it continues, 'just being on the Dove is enough'.

The Wye is also famous among fishermen, particularly for its naturally breeding population of rainbow trout. It is frequently stocked for syndicates, hotels and others who pay for the fly fishing.

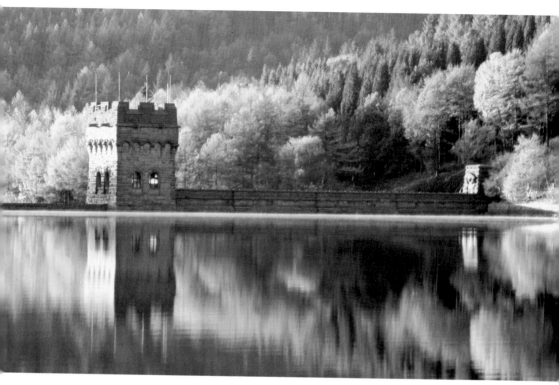

The reservoirs and the beautiful valley, in which they lie, have since become a major tourist attraction. (Copyright & courtesy of Robert Falconer)

The upper reaches of the Derwent are also renowned for good fly fishing with plenty of trout and grayling, while as the river runs down below Matlock an increasing number of coarse fish are to be found, including barbel and chub. Even the smaller rivers have a lot to offer. Charles Cotton wrote about the Lathkill in *The Compleat Angler*: 'It is by many degrees the purest and most transparent stream that I ever yet saw, either at home or abroad, and breeds 'tis said the redest and best trouts in England.' The Lathkill is still one of the Peak District's key trout-fishing rivers. More recently, as you will see in Chapter 9, fishermen have been surprised to see something rather larger trying to leap some of the many weirs along at least two of Derbyshire's rivers.

Tourist Attraction
With its rugged moorland, rolling hills and dales, lush meadows, historic houses and fascinating old market towns, the Peak District would seem to have everything to appeal to the country-loving tourist. But despite all this, many would agree with writer J. H. Ingram, who wrote in 1995 that 'The chief joy of the Peak district is its rivers, and it is doubtful if any other region can show such a group of glorious streams.'[4] Probably the most visited of all those 'glorious streams' is the Dove.

The next chapter takes a brief look at the Dove's entire course before considering in more detail the attractions on her banks.

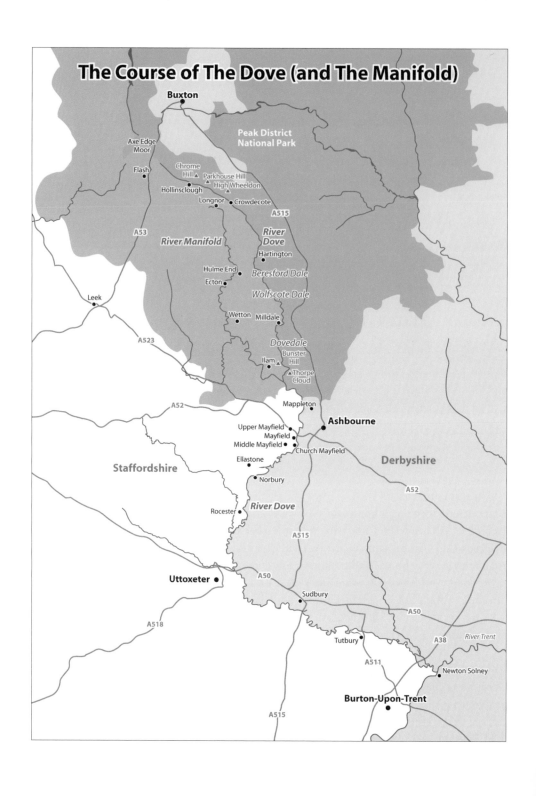

The Course of The Dove (and The Manifold)

Buxton

Peak District National Park

Axe Edge Moor

Flash

Chrome Hill ▲ Parkhouse Hill ▲ High Wheeldon ▲

Hollinsclough

Longnor • Crowdecote

A515

A53

River Manifold

River Dove

Hartington

Hulme End

Ecton

Beresford Dale

Wolfscote Dale

Leek

Wetton • Milldale

A523

A52

Dovedale

Ilam ▲ Bunster Hill

▲ Thorpe Cloud

Mappleton

Ashbourne

Upper Mayfield

Mayfield

Middle Mayfield

Church Mayfield

Ellastone

Staffordshire

Derbyshire

Norbury

A52

Rocester •

River Dove

A515

Uttoxeter •

A50

Sudbury

A50

A518

River Trent

Tutbury

A38

A511

Newton Solney

Burton-Upon-Trent

Chapter 2
The River Dove

The Dove is the main river of the south-western Peak District. Her name comes from the old British word 'dubo', meaning dark. She rises close to the A53 Leek to Buxton road and her clear waters run southwards for about 65 km (40 miles) to her eventual confluence with the River Trent. She is very much a walker's river, being almost inaccessible by car. It is possible to walk down her first 20 miles and intermittently along the rest. For much of her way, the Dove forms the boundary between the counties of Staffordshire (to the west) and Derbyshire (to the east).

The Course of the Dove

From the surrounding rugged grandeur of Axe Edge, the waters of the Dove, though only a stream to begin with, form a pronounced valley within only half a mile of her origin.

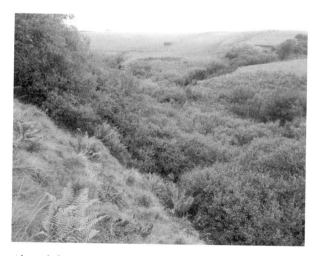
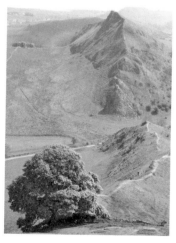

Above left: Just a stream at this stage, the Dove plunges steeply down through a wooded valley.

Above right: The cockscomb ridges of Chrome and Parkhouse hills form a magnificent backdrop for many of the villages of the upper Dove.

Farm animals graze, drink and relax at the water's edge along much of the dales.

Longnor's cobbled market square was once the heart of a thriving trade centre for the region.

Many packhorse routes cross these first few miles of the River Dove. These old trails have now become footpaths, often with only a single stone slab to form the river crossing. The River Dove widens as she arrives at the limestone rock, around Hollinsclough. Following the boundary between the limestone on the Derbyshire bank and the shales on the Staffordshire bank, hills rear up all around in strange shapes. On the left bank of the river, Chrome and Parkhouse hills form their magnificent cockscomb ridges.

The river moves on past High Wheeldon, a large rounded hill with a cave that has yielded Mesolithic remains. Artefacts found here are exhibited at the Buxton Museum and Art Gallery. Below the interestingly named hamlet of Glutton, the river trickles along in a deep and fairly wide valley, passing under a road bridge in Crowdecote which, like many of the road bridges along the Dove, takes the traveller over the river from one county to another.

The Dove flows on, with a limestone ridge on its left bank and a gritstone one on its right, past Pilsbury and Sheen. The opposing rocks on either side of the river have a huge affect on the vegetation and the wildlife, so that different species can be found on different banks. This part of the valley has twice been threatened by plans for a reservoir, which fortunately haven't come to fruition. In 1946 the House of Lords threw out a plan by Leicester Corporation and in 1970 a scheme by the Trent Water Authority was also abandoned due to local opposition.

Just west lies the Staffordshire village of Longnor, standing between the Dove and the River Manifold, at the junction of a number of formerly important turnpike roads

Local industrialist Jesse Wye Russell had Ilam Hall and village rebuilt in the nineteenth century.

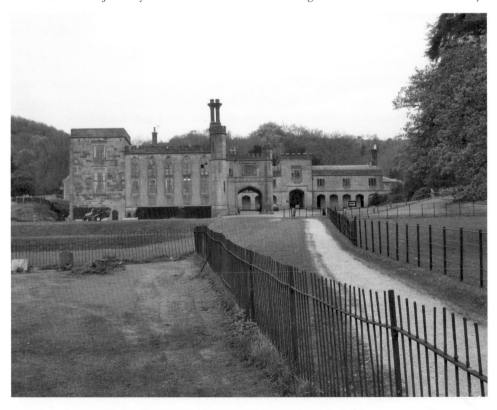

The boil holes in Ilam Park, where the waters of the Manifiold emerge from an underground journey to join the Dove.

which crossed the Staffordshire moors. Longnor was once a thriving market centre for the region. Sadly, however, its popularity declined with the demise of the turnpikes and its lack of a railway link.

The river flows on past Longnor to bypass the village of Hartington on the Derbyshire side. Hartington is the focal point for the northern end of the beautiful limestone dales of the River Dove and gateway to some of the most popular riverside walks in Derbyshire. It is hugely popular with tourists whatever the season.

Just beyond Hartington, accessed by a footpath leading out of the village across fields, begins the most famous section of any Derbyshire river as the meadows end and the river cuts through a series of stunning limestone gorges. Beresford Dale, Wolfscote and Dovedale have all become legendary, visited for centuries by generations of visitors. The tiny village of Milldale lies between Wolfscote Dale and Dovedale. This is a popular place, with a car park, shop and toilets. It is also home to Viator's Bridge, the crossing of which takes you into the legendary Dovedale itself.

It is not only the clear and gently flowing waters which make Dovedale so attractive to visitors then and now. It is a magical place from start to finish with ancient woodlands along its banks, a multitude of wild plants and flowers and the great

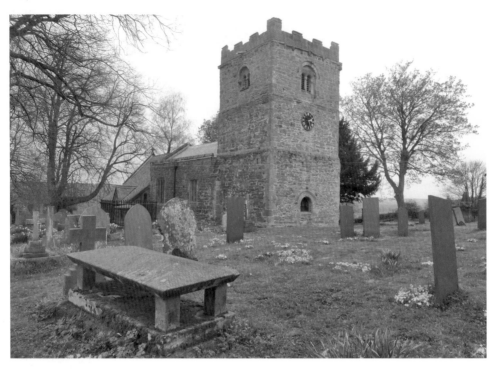

The church in Thorpe village has a Norman tower built in the days of King Stephen.

The Dove is a much bigger river now (seen here approaching Mappleton), supplemented by the waters of both the Manifold and the Hamps.

On New Year's Day many people jump 30 feet from this bridge into the icy waters of the Dove below.

limestone buttresses often rising sheer from the river banks, which the Victorians (as was their habit) gave names to.

It takes just over an hour to stroll from Milldale, along the most walked along path in Derbyshire and crossing over the stepping stones to the Staffordshire side of the Dove, to the car park at the base of Thorpe Cloud. This is the end of the gorge. The river flows swiftly on through the village of Ilam (pronounced 'eye lamb'), an immaculate village in a spectacular location. With its Swiss-style chalet housing and Gothic mansion, known as Ilam Hall, standing in an extensive country park, Ilam is a popular place with visitors.

Ilam Hall and Country Park now belong to the National Trust. The hall and grounds are used as a youth hostel, tea rooms, shop, information centre, car park and toilets. What's left of the hall is still an imposing and stately structure and in the gardens and parkland there is much to see. It is just below the village of Ilam, in the grounds of the country park, that the River Dove meets the River Manifold.

Overshadowed by its more famous neighbour, the River Manifold is still a beautiful river, with a lower section almost as spectacular as Dovedale. It seems a little unjust, therefore, as the Manifold is easily the larger, that the combined river from this point onwards is called the Dove. The river meanders on through gentler countryside now, bordered by some fascinating historic towns and villages that cling to peculiar ancient customs. It first passes west of the 1,000-foot-high Thorpe Cloud, which either gives or takes its name from the

Mayfield's Hanging Bridge.

Terrified villagers sought refuge from Bonnie Prince Charlie's rampaging troops in Mayfield's St John's church.

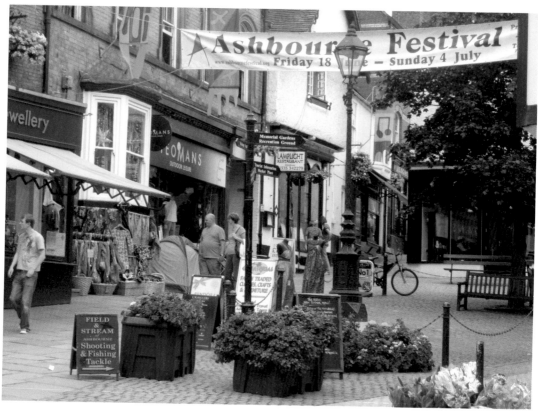

Ashbourne is a small market town, rich in festivals, folklore, history and architecture.

village beneath. Leaving Ilam Country Park the Dove passes through rural farmland, close to the village of Mappleton (sometimes spelt as Mapleton) famous for its annual New Year's Day charity bridge jump into the icy waters of the river.

Bordering the Okeover Estate on the Staffordshire side, the Dove rushes on at a more furious pace to a much larger bridge that carries a steady procession of traffic over the busy A52 road, at the three-part village of Mayfield. A famous bridge for a very different reason to that of Mappleton Bridge, this is where some of Bonnie Prince Charlie's troops were reputedly hanged in 1745 after they had terrorised Mayfield villagers during their retreat from Derby.

Joining the river at Mayfield is Henmore Brook which flows directly down from nearby Ashbourne, the picturesque market town known as the Southern Gateway to the Peak. Ashbourne too is home to an unusual ancient custom celebrated annually, this time over two whole days. During the town's Royal Shrovetide football match, one half of the town plays the other half in a match with a difference. The playing field comprises the town and its surrounding countryside, the leather ball is stuffed with sawdust and the two goals are 3 miles apart!

Flowing swiftly away from the Peak District now, the Dove flows on, passing through small agricultural settlements. She passes the site of an old abbey, famous for snowdrops and rumoured to be the place where Handel was inspired to write

Sudbury Hall, now owned by the National Trust, welcomes thousands of visitors a year who come to view its spectacular interior and walk in its peaceful lakeside gardens.

his *Water Music*. Ellastone, a little further downstream, boasts of her links with the novelist George Eliot, proudly proclaiming itself to be 'Adam Bede Country'. Past the peace and tranquillity that surround the thirteenth-century manor house in Norbury, with its adjacent church and Tudor hall, the river rushes on to be confronted, a few kilometres downstream in Rocester, with an abrupt awakening to the industrial age.

Passing about 2 km east of Uttoxeter, the river continues under two bridges at Doveridge. The road bridge over the river is of modern construction and lies side by side with the original Dove Bridge, which was probably built in the fifteenth century with six arches constructed of local stone. The older bridge is now used only by cattle and local farm traffic.

Doveridge is also a place of history and legend – especially the church, which is over 900 years old and has a historic peal of bells. Like its neighbouring village Sudbury, a couple of kilometres further down the Dove, Doveridge was once dominated by its eighteenth-century hall which commanded superb views of the river. While Doveridge Hall was demolished, Sudbury Hall remains, dominating the skyline with its golden-topped dome.

Like Doveridge, the heart of Sudbury village has thankfully been preserved by a modern bypass constructed in 1972. This carries the traffic, which thunders through middle England, over the River Dove and away from these ancient villages. Following the course of the river downstream, the battered remains of Tutbury Castle appear silhouetted against the skyline. A key centre of power in medieval England, the castle has been destroyed and rebuilt several times during its turbulent history. Still a fascinating place to visit, it plays host to a series of original and imaginative historical events and re-enactments, including a 'Buffet and Talk with Elizabeth I', who had Mary Queen of Scots imprisoned there four times.

Close by stands Tutbury parish church, now all that remains of the extensive buildings of Tutbury Priory, originally a 3-acre site extending down to the banks of the Dove. The religious houses of Tutbury Priory, Burton Abbey and Repton once owned much of the land in this area. They provided essential social services, such as caring for the poor and elderly and providing hospitality to travellers and sanctuary to fugitives. Their dissolution between 1534 and 1538 meant that new burdens fell on the community, such as the maintenance and repair of Monk's Bridge near Eggington, which the Burton Abbey monks had previously built and maintained.

In 1926 Monk's Bridge was bypassed by a new A38 road bridge. Another impressive bridge over the river near Eggington is a 12-acre aqueduct, built by canal engineer James Brindley in 1770 to carry the Trent & Mersey Canal over the Dove. In 1840 the Birmingham & Derby Junction Railway also bridged the river. Just a couple of kilometres downsteam, the Dove finally reaches her confluence with the River Trent at Newton Solney.

A small and picturesque village, on the southern bank of the river, Newton Solney was once an agricultural settlement under the ownership of the Every family. However, when, like many of the great landowning families, they fell into debt, Newton Solney came under the influence of a succession of wealthy benefactors who made it the immaculate and interesting village that it is today. Newton Solney is now mainly a commuter village for the nearby centres of Burton and Derby. But its history stretches back as far as the sixth century, when Anglina invaders travelled up the Trent and considered this an excellent place strategically to base a settlement, just west of where the Dove joins the Trent and where the Trent could be easily forded.

Since then, many more settlements have grown up along the banks of the Dove, using her waters for a wide variety of purposes. The remainder of this book looks in more detail at the settlements and points of historical interest along each section of the Dove. For the purpose of describing her attractions, those sections have been labelled as 'upper', 'middle' and 'lower', though these terms are not generally used.

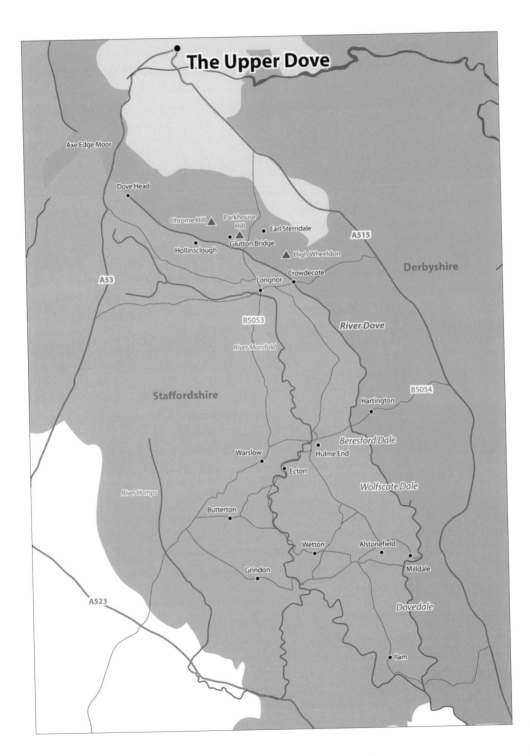

The Upper Dove

Axe Edge Moor

Dove Head

Chrome Hill

Parkhouse Hill

Earl Sterndale

Glutton Bridge

Hollinsclough

High Wheeldon

A515

Crowdecote

Derbyshire

Longnor

A53

B5053

River Dove

River Manifold

B5054

Staffordshire

Hartington

Beresford Dale

Warslow

Hulme End

Ecton

Wolfscote Dale

River Hamps

Butterton

Wetton

Alstonefield

Milldale

Grindon

Dovedale

A523

Ilam

Chapter 3

Some Villages and Peaks of the Upper Dove

The upper Dove Valley is one of the quietest parts of the Peak District, yet it contains some of its most spectacular scenery. Driving along the narrow roads between the numerous small villages and hamlets, you twist and turn over small and often ancient stone bridges. One minute you are in Derbyshire and the next you are on the opposite bank in Staffordshire, which can be a disorienting experience. The whole area, compared with other parts of the Peak District, is comparatively little visited; but with its carved raw peaks, its sheep-flecked, wind-blasted hillsides and its stark but quaint (sometimes quarry-blasted) hamlets and villages, the whole area is seriously underrated. It also has some quirky tales to tell.

This chapter follows a circular drive, stopping off at some of the most characterful villages of this area that nestle beneath the awesome backdrop provided by Chrome, Parkhouse and High Wheeldon hills. For the more energetic, a walk is recommended which includes a steep but fairly short climb to a bird's-eye view of this northernmost region of the Dove from the summit of its most spectacular peaks.

The Road to Crowdecote

The villages of the upper Dove Valley lie just a short distance from the river's origin on Axe Edge just outside Buxton. They can be approached by car from a number of small roads leading off west from the much-travelled A515 between Buxton and Ashbourne. Possibly the most spectacular approach is about 6 miles out of Buxton down a small lane signposted Hurdlow, Crowdecote and Longnor. After turning off the A515 you will almost immediately come to the Hurdlow junction of the High Peak Trail, a popular cycle trail and footpath. Continue down the lane where, after a couple of kilometres, broad vistas of landscape begin to open up unexpectedly below as you begin the long winding descent of High Needham Hill. Odd jagged peaks reaching skyward start to come into view as the road twists and bends like an alpine descent through some ferocious hairpin bends. Only when you finally reach the little-known hamlet of Crowdecote, nestling deep in the valley on the Derbyshire bank of the upper Dove, can you finally take your eyes off the road in order to appreciate the scenery.

The village's interesting name is thought to be a corruption of Cruda's Cot (Cruda was a Saxon landowner and a cot is a form of shelter). There are the remains of an old

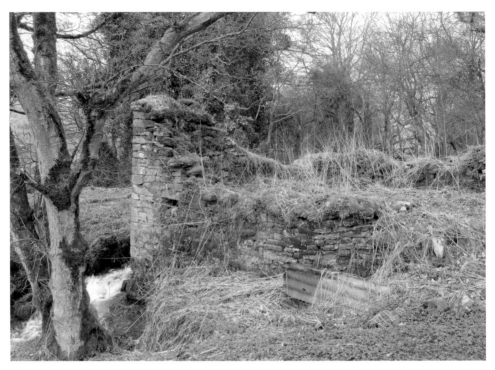

Little remains of Crowdecote Mill beyond a heap of crumbling stones and a hole in the bank where the waterwheel used to be. The watercolour below, painted over 100 years ago, gives a better impression of how it once looked.

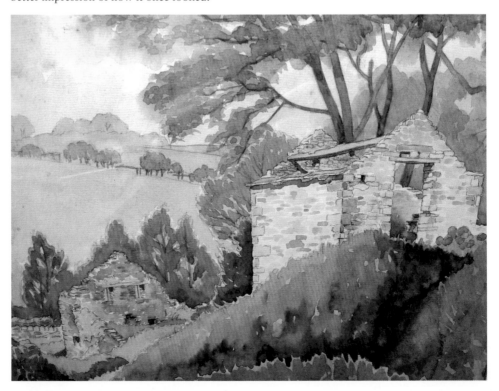

Chrome and Parkhouse hills, from Crowdecote.

corn mill here, one of several in the area where locally grown oats and occasionally barley were ground to produce oatmeal and process barley for beer making.

From the village you get a fine view of the conical-shaped Chrome and Parkhouse hills which completely dominate the scenery of this area. These are fine examples of reef knolls, originally coral reefs formed by billions of polyps in the Carboniferous sea. When the softer surrounding limestone was eroded away, the reefs remained, rich in marine fossils.

Just beyond the village, the road crosses a bridge which takes you over the Dove, immediately into Staffordshire. Like many of the bridges over the rivers in this area, this was constructed (or adapted in this case) to allow heavily laden packhorses to cross.

The Packhorse Trails

Most of the inter-village routes of this area today originated as packhorse routes. Silk woven in Hollinsclough, for instance, was transported by packhorse to the silk mills at Macclesfield, cheese was transported from Cheshire, and copper extracted from the Ecton mines was taken for smelting in Denby. Medieval packhorse trails were maintained by fees paid by the users and with labour provided by the residents of each parish along the way. Trails of up to forty animals were maintained by a 'Jagger', an overseer named after the Jaeger breed of horses favoured for this work. Each horse could carry up to 113 kg (250 lb) of goods in panniers easily transferred to fresh horses when necessary.

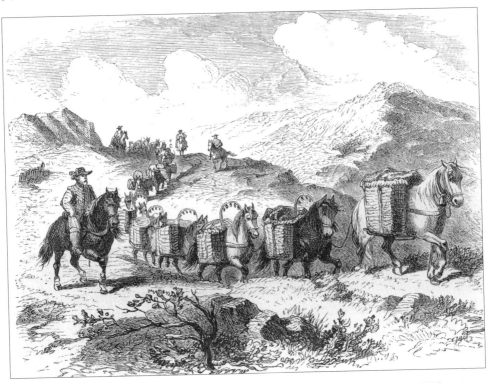

Packhorse trails of up to forty animals were once a common sight in this area. (DCHQ006374. Courtesy of Derbyshire Local Studies Library and www.picturethepast.org.uk)

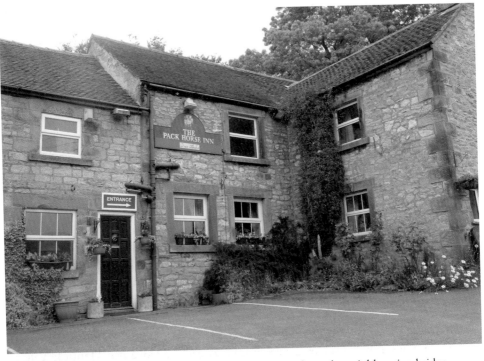

The popular Pack Horse Inn at Crowdecote takes its name from the neighbouring bridge.

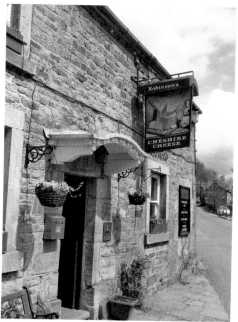

Above left: Tolls were collected from 'Toll Bar Cottage' in Crowdecote, which still bears this name.

Above right: The Cheshire Cheese Inn recalls Longnor's past trading links with Cheshire.

The area's many isolated pubs provided staging and business points for the packhorse trails.

The busy packhorse routes were gradually superseded by turnpike roads built by turnpike trusts who levied tolls to maintain and improve the highways. These wide new roads were developed with mail coaches and carriages in mind. The road through Crowdecote became part of a popular turnpike route. The toll gates were 'thrown open' in 1873, however, and both toll and toll gates are now long gone.

The turnpike route through Crowdecote is one of many that lead from Longnor, once a thriving market centre for the region. You can reach Longnor, the largest settlement in this area north of Hartington, if you cross over the bridge into Staffordshire and continue along the road for 1 mile.

Longnor

The village of Longnor was once prosperous as the crossing point of a number of key packhorse and later turnpike roads. Sitting on the side of a ridge, between the Dove and the Manifold, it was a thriving market centre for the region. Many trails came in from Cheshire heading first for the village of Flash (which at over 1,500 feet claims to be the highest village in England), at the southern end of Axe Edge. These then took the lane along 'Edge Top' (now tarmac covered) between the Dove and Manifold Valleys, heading for Hollinsclough and then on to Longnor.

The first record of the church of St Bartholomew's construction is in 1223 and the church contains a Norman font. Rebuilt in the eighteenth century, however, it is largely the Elizabethan construction that we see today. It was altered to increase its height in the early eighteenth century, and again after a fire in 1883.

There was a depot in Longnor where carriers could deliver packages for collection by other carriers, for onward movement to their next destination, which may have been Bakewell (via Crowdecote Bridge), Leek, Hartington or beyond. Goods were sometimes left at a particular pub for collection. The copper mine at Ecton, just down the River Manifold (see Chapter 7), regularly did this.

Some idea of the sheer volume of packhorse traffic which passed between Longnor and Leek can be seen at Lane Farm just south-west of the village. Here a huge hollow way has been created purely by erosion from the feet of horses. Another link to Longnor's trading history with Cheshire, still visible today, is the Cheshire Cheese Inn, centrally located in the village. Trading took place from a cheese store directly opposite the inn, which possibly dated back as far as 1464. Sadly, this was demolished as it jutted out into the road too much.

Longnor's heyday was the eighteenth century and many of the village-centre properties date from this era. Older buildings such as the corn mill on the road to Leek were rebuilt, as well as the church which was rebuilt in 1782. Despite all the trading links, the village used locally produced materials wherever it could. Stone for building work came from local sources. Many buildings in the village were built with gritstone mined at Daisy Knoll mine on the road to Hollinsclough. Coal for the village was mined

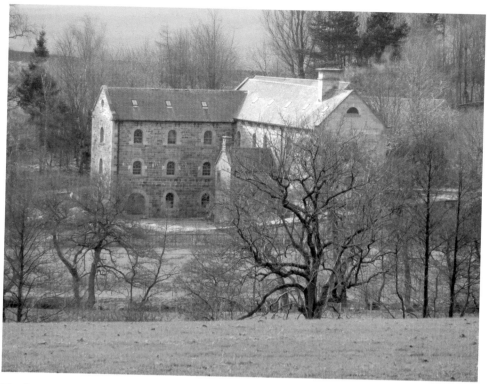

The first record of Longnor Mill was in 1404, but it was rebuilt in 1605 and 1769. Work is now under way to restore it.

on Axe Edge and lime came from the lime kilns in Buxton for mortar and spreading on fields. Locally grown oats were ground at Longnor and Crowdecote mills.

Longnor prospered and by the early nineteenth century had seven public houses. But with the demise of the turnpikes in the nineteenth century Longnor's development stalled. There was talk of extending the Leek & Manifold Light Railway (see Chapter 7) to Longnor, but sadly this remained just an idea. The Ashbourne to Buxton line built in 1890 also bypassed the village. Sadly, Longnor's railway link never arrived and other communities linked by the railway – such as Leek, Buxton, Bakewell and Ashbourne – all thrived at Longnor's expense.

Longnor Today
Today this once prosperous and still characterful village is popular with walkers and cyclists. Many of the old packhorse routes are now footpaths which allow you to explore the attractive, little-known and sometimes spectacular scenery of the upper reaches of the Dove and Manifold valleys. The village clusters around its little cobbled Market Square next to the Victorian Market Hall, dated 1873.

Longnor Sports
Like many of the Dove villages, Longnor clings on to her traditions. The village hosts an event which attracts thousands of visitors every year, dating back to 1904. The annual

Many of the village-centre properties were built of local gritstone during Longnor's period of prosperity in the eighteenth century. Many still bear the name of the trades of their occupants.

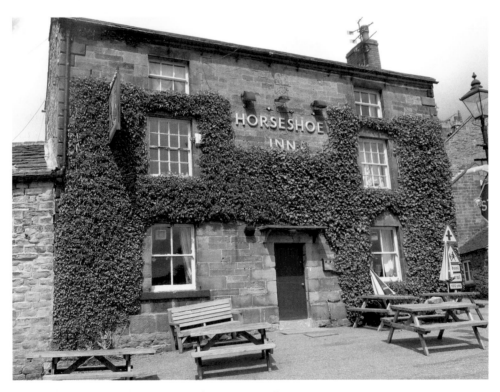

The Horseshoe Inn is the oldest still-active pub in Longnor, dating from 1609, although it has probably been re-fronted. Recently its façade was used as the exterior of the 'Black Swan' in ITV's *Peak Practice*.

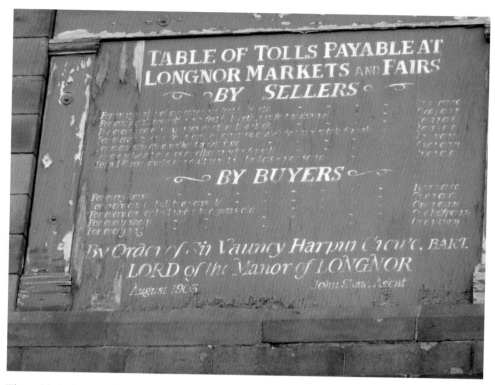

The gabled nineteenth-century Market Hall is now a craft centre and coffee shop, but there is still an inscription above the entrance, detailing the tariffs of long-forgotten market tolls.

'Longnor Sports' or 'Wakes races' are held on the Thursday after the first Sunday in September, at Waterhouse Farm. The day starts around noon with a gymkhana, followed by a series of harness races. These are followed by a 'Golden Mile' fun run which anyone can enter, then motorbike races and a final cross-country hill race to round off the day.

Another village which works particularly hard to keep its traditions and folk memories alive is Hollinsclough. To reach Hollinsclough from Longnor, turn right at the crossroads (signposted Buxton and Glutton Bridge), then on the outskirts of the village take a left turn signposted Hollinsclough. After about 1 km take the signposted right turning which takes you northwards, back upstream of the River Dove. Enjoy some fantastic views of the curving ridges of Parkhouse and Chrome hills as you approach the village.

Hollinsclough

Hollinsclough, further north than Crowdecote or Longnor but still on the Staffordshire side of the Dove, has neither shops nor pubs, but is a delightful and immaculately kept, picturesque village with a thriving community association. With a spectacular backdrop of the awesome Chrome and Parkhouse Hills, it makes an ideal take-off point

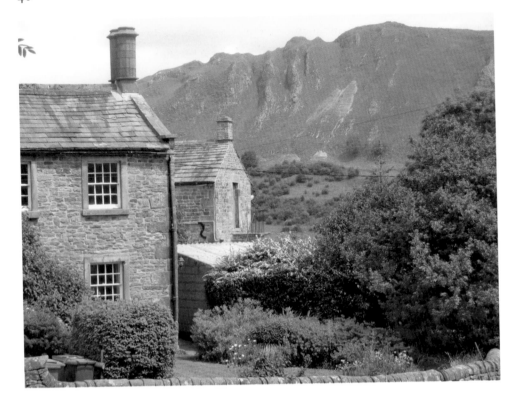

Above: Hollinsclough nestles beneath 'The Dragon's Back'.

Left: Trails of packhorses carried silk from weavers' homes along Limer Rake (named after a family called Limer, whose members have lived near to the top of the Rake for some 200 years) and other trails, and on to Macclesfield.

from which to enjoy a scramble up on to the fine ridge walk, which crosses Chrome Hill – locally and appropriately known as 'The Dragon's Back'.

The name of this settlement comes from the clough that descends from Hollinsclough Moor, just south-west of the village. Back in the eighteenth century the village had a thriving silk-weaving cottage industry. Local weavers worked from their homes. When the material was complete it was transported by packhorse to the silk mills in Macclesfield. You can still see the remains of the weaving 'shed' of Emma Limer, the last local silk weaver, at the top of Limer Rake.

Another well-frequented packhorse route comes directly down from Axe Edge Moor. It passes by a chapel built by John Lomas in his own back garden in 1801. John Lomas was a member of a small delegation of 'pedlars and hawkers' who went to see William Pitt (the then Prime Minister) when, in 1785, the government proposed the abolition of licensed hawkers. They went to argue their case at the bar of the House of Commons. A petition signed by Lomas and other local traders helped to bring about a change of mind.

After listening to one of John Wesley's preachers, both Lomas and his wife Sarah became Methodists and in 1785 formed a Methodist society which had eleven members. His chapel was registered in 1797, with Lomas as minister. He kept a journal from 1783, the year of his conversion, to 1823, the year of his death, and it has provided a lot of useful historical information about the area at this time. John Lomas and his wife Sarah are buried in the vault at the head of the aisle in the chapel. There is a memorial tablet on the wall.

There is still a thriving school in the village, situated behind its nineteenth-century predecessor, the Frank Wheldon School. While their women weaved silk, Hollinsclough men used to mine calamine from Chrome Hill. It was found quite close to the surface and if you look carefully you can still see some of the old diggings. The lumps of ore were taken down to Cheadle to be used in brass making.

Walking along The Dragon's Back

Locally pronounced 'Croom', Chrome Hill (430-m/1,411-foot summit) is thought to have taken its unusual name from the Old English 'crumb' meaning curved or sickle-shaped. This is a perfect description of the curving ridge which provides one of the finest ridge walks in the Peak District.

Weaving and dipping between limestone outcrops, small caves and arches, the path requires a reasonably good head for heights and includes one steep climb. It is a circular walk of about 7 km and takes about three hours to complete.

Directions
1. Park in Hollinsclough, close to the small triangular-shaped village green. Take the lane that heads eastwards out of the village, past the new and old school with its dovecote tower.
2. Continue down this lane, passing by one signed footpath to the left. Take the second footpath on the left and follow this as it heads across the fields in the

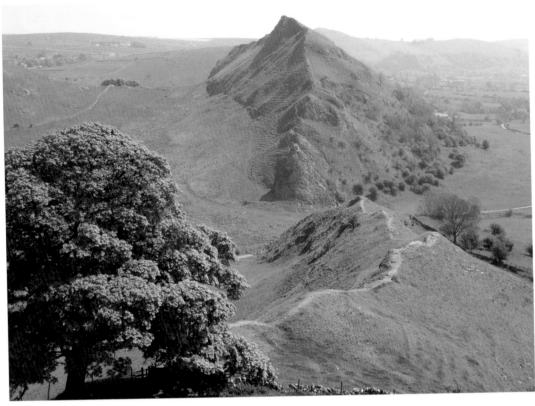

The views from the curving ridge of Chrome Hill are outstanding.

direction of Parkhouse Hill, keeping to the left of the brook that runs down to meet the Dove.

3. Go through a small gate and follow the path, still keeping to the left of the brook as you follow the path down towards the footbridge over the Dove at the foot of Parkhouse Hill.

4. Continue over the footbridge which takes you into Derbyshire. You can enjoy some fine views of Parkhouse Hill as you walk up the gravel path. Follow the path up to a tarmacked lane, then turn left up the lane.

5. After a short distance you will see a signed footpath leading over a stile to your left, which leads you onto the permissive footpath to ascend Chrome Hill.

6. Follow the clearly marked path up the incline (steep at times) to the summit of Chrome Hill. Here the outstanding views extend as far as Axe Edge to the west and the outline of Kinder Scout beyond Buxton to the north. Closer to hand you will be able to see down the length of the Dove and neighbouring Manifold Valleys.

7. Continue over the hill and descend via the western ridge, keeping a close eye on your feet as the path twists and turns between limestone outcrops and can be a little hazardous in places.

8. A waymarked path will lead you across the eastern flanks of Tor Rock until you reach the Stoop Farm access road. Follow the signposted path up a hill and then

alongside walls, through two small gates to a wooden signpost. Follow the sign pointing in the direction of 'Booth Farm', across fields to the tarmacked track.

9. Turn left along the track which soon bends right towards houses and farm buildings. Take the path which forks left from the buildings to descend to the Dove once again.

10. Cross over the river via Washgate Bridge and follow the rights of way back on the Staffordshire side of the river back to your starting point at Hollinsclough.

Further north, a little farther from the river and this time on the Derbyshire side, lies the village of Earl Sterndale which, despite the massive amount of quarrying that takes place on the other side of the hill, still manages to retain an air of peace and tranquillity. To reach Earl Sterndale from Hollinsclough, drive down the lane which leads eastwards through the village, past the new and old school with its dovecote tower. Continue for a couple of kilometres up the narrow lane to a junction, then turn left.

You will pass through the hamlet of Glutton Bridge, where the bridge will take you back over into Derbyshire. Just beyond Glutton Bridge, a right turn will take you into the village of Earl Sterndale.

Earl Sterndale

East Sterndale has two claims to fame. The first is that it is the only Derbyshire church to be bombed during the Second World War.

St Michael and All Angels' church replaced a Norman chapel that originally stood on the site in 1828–29. The font is the only surviving Norman relic.

On 9 January 1941 a stray incendiary bomb landed on the church. It is thought that the target was actually DP Battery in Bakewell, where submarine batteries were produced. The church was locked at the time and before access could be gained, the roof timbers, pews and interior decoration were burnt and totally destroyed. The church was rebuilt in the 1950s and there is a plaque inside and various newspaper articles which recall the day the bomb fell on it.

The Quiet Woman

Earl Sterndale's second claim to fame is the unusual name of its village pub: The Quiet Woman. It is said to be named after a previous landlady who was known to the village as a 'Chattering Charteris'. As the woman grew older her talking got worse, lasting well into the night, driving her husband to distraction. Eventually, he had had enough. He took an axe and chopped off her head as the only sure way to silence her.

The pub sign bears the inscription 'soft words turneth away wrath', a warning to other wives not to emulate her fate! It would seem that she had the last laugh, however, as rumour has it that she returned as a ghost to frighten away her husband's customers.

Flower Festivals

Like many local villages, Earl Sterndale holds an annual flower festival in the church which

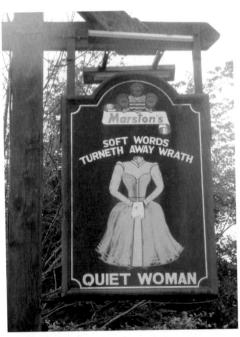

Above left: The 'woman' is quiet because she has no head! 'Chattering Charteris' wearied her husband so much that, at last, he cut it off.

Above right and opposite: The charm and quiet of Earl Sterndale with its large green duck pond and peacefully grazing donkeys belie the huge amount of quarrying that takes place just behind the hill.

takes place in August. The church remains open for several days for visitors to view the beautiful and often themed displays and to enjoy refreshments, tombolas, raffles and sales tables. In 2010 the church raised £700 at its bridal-themed twenty-second annual flower festival 'To Have and to Hold'. The proceeds are used for the upkeep of the church.

High Wheeldon Hill

Just behind Earl Sterndale looms the third great hill that dominates the landscape of the area, High Wheeldon Hill. The summit of High Wheeldon (422 m/1,383 feet) provides another of the finest viewpoints in the White Peak.

 If you drive straight through Earl Sterndale, you will soon arrive at the access point for the walk up High Wheeldon Hill, on the left, about half a kilometre outside the village. The hill is a much easier and quicker climb than Chrome Hill, with some equally rewarding views. (It is about a 40-minute return trip to follow the clearly marked path from the access point up to the summit and back.)

 This hill was given to the nation as a memorial to the men of Derbyshire and Staffordshire who fell in the Second World War, and then made over to the National Trust. On a clear day, if you look north-east from the summit, Longstone Edge above Bakewell can just be made out, as can Chelmorton Low and Eldon Hill, towards Castleton. Just below the summit to the north-east is the locked entrance to Fox Hole Cave, where Stone Age remains have been discovered in a 180-foot-long (54 m) fissure-type chamber.

Return to Crowdecote

Drive on for about 1 km to return to the village of Crowdecote to complete the circular drive.

Chapter 4

Hartington and Beresford and Wolfscote Dales

While Longnor provides a firm base from which to explore the hills, peaks and characterful small hamlets and villages of the upper Dove, Hartington is the northern gateway to the riverside walks of her mid-regions, some of the most celebrated in England.

Beresford Dale, Wolfscote Dale leading to the village of Milldale, and then most famously Dovedale, have all become legendary, visited for centuries by generations of tourists, many inspired by the writings of Izaak Walton and Charles Cotton, who spent so many happy hours fishing and writing here.

This chapter takes a look at the village of Hartington, its sometimes turbulent history and what it has to offer today's visitor, before moving on down the Dove to explore the beautiful dales. The recommended walk is less strenuous than that of the previous chapter, involving a flat stroll down riverside paths, with an opportunity to extend a linear walk into a circular route.

Charles Cotton and Izaak Walton

Charles Cotton was born at Beresford Hall, which once stood above Beresford Dale, in 1630. His father was a wealthy landowner with many literary connections. When his father died he left Charles considerable estates at both Beresford and Bentley, but he also left his son considerable debts. An extravagant lifestyle, with long periods spent fishing rather than earning money to pay off his accumulated debts, meant that Cotton had to sell the hall in 1681. (Sadly, it was demolished in the late 1850s with the intention for it to be rebuilt, but this did not happen.)

It was while fishing the Dove in Beresford Dale that Cotton first met Izaak Walton. Though Walton was forty years his senior, the two became firm friends. In 1674 Cotton erected a memento of Walton's friendship in the form of 'a little fishing house' on the banks of the Dove in Beresford Dale. Though very little now remains of Beresford Hall, the fishing temple still stands on private land today.

Two years later Cotton wrote the celebrated second part of Walton's fifth edition of *The Compleat Angler*. As well as being the greatest ever classic of angling literature with advice for catching and cooking fish, rules for baits and tips on the making of artificial flies, the book provides a unique celebration of the English countryside at this

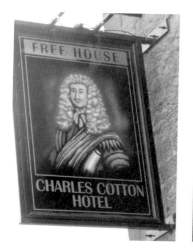

Above, left and right: The Charles Cotton Hotel in Hartington, and the Izaak Walton Hotel at the lower end of Dovedale near Ilam, pay tribute to the two friends and writers who first put the Dove on the tourist map.

time. It revolves around two companions, Piscator and Viator, who each dilate on the joys of their favourite sport. Their discourse refers to many points of interest along this stretch of the Dove which are still relevant today.

Externally the fishing temple looks much the same today as when it was built. Over the doorway you can see the square panel which bears the inscription, 'PISCATORIBUS SACRUM 1674'. Beneath this lies a stone forming the key of the arch on which a monogram is carved displaying the entwined initials of I. W. and C. C. – 'the two first letters of my father Walton's name and mine twisted in cypher', which Walton saw 'cut in stone before it was set up'.

Internally, Viator paints a charming picture. His suspense is delightful as he approaches the temple for the first time:

> I dare hardly go in, lest I should not like it so well within or without; but by your leave I'll try. Why, this is better and better! Fine lights, finely wasitcotted, and all exceedingly neat, with a marble table and all in the middle.

It is not difficult to picture the two friends and anglers sat smoking their pipes which Cotton tells us 'was commonly with breakfast' inside or just outside their delightful hut.

The Village of Hartington

The footpath leading down from Hartington past the fishing temple to Beresford Dale is just one of a network of footpaths centred around the village of Hartington. This is the major village on this section of the valley of the Dove with more an air of a prosperous town than a village. Although Hartington no longer has a market, its

River Dove

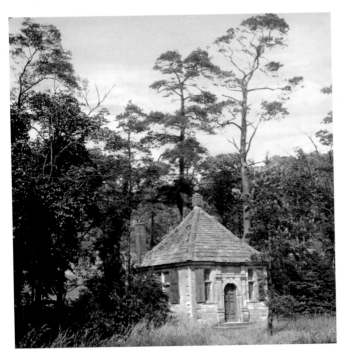

Left: 'I am most pleased,' says Viator in *The Compleat Angler*, 'with this little house, of anything I ever saw.' Cotton and Walton's fishing temple can still be seen from the footpath leading from Hartington into Beresford Dale, although it stands on private land. (DCBM 200214 Courtesy of Buxton Museum & Art Gallery and www.picturethepast.org.uk)

Below: The carved stone village pump survives on the green, and was an important source of water before piped supplies were brought to the village.

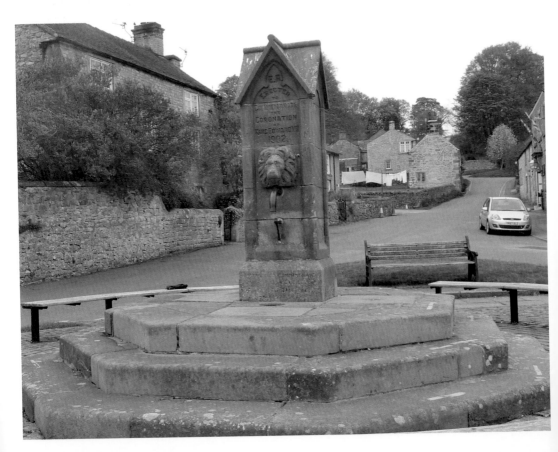

location has led to it becoming an important tourist centre, so it can get very busy at summer weekends.

Hartington is an old village with a modest entry in the Domesday survey of 1086 when the hamlet covered only 16 acres of meadow, a few square furlongs of underwood, some waste and only enough taxable land for a couple of ploughs. It is mentioned as being worth 40 shillings and belonging to Henry de Ferrers, who, as we will see in Chapter 10, was a significant figure in Derbyshire at this time. Hartington was one of many estates that William I (the Conqueror) gave to Henry de Ferrers in return for his conspicuous bravery and support at Hastings, his most important estate being in Tutbury, close to the southern end of the Dove.

Granted a market charter in 1203, the village still held three annual fairs in the nineteenth century, as well as a weekly Wednesday market specialising in butter and eggs. Weekly markets and fairs were held for almost 700 years but then gradually went into decline. With a long history, the village was the centre of several skirmishes between the Royalist 'Cavaliers' and the Parliamentary 'Roundhead' troops during the Civil War.

It has some characterful old buildings which have played host to some interesting visitors. The architecture which now surrounds the village centre is an indigenous mixture of large, late eighteenth and early nineteenth-century buildings, blended with the smaller cottages of an earlier and more rustic period. The village provides for tourists as well as local people, and there are several tempting cafés, quality gift and craft shops and a newsagent.

Wakes and Well Dressings

Like many Derbyshire towns and villages, Hartington has celebrated her wakes (annual fête and week of festivities) every year with stalls and well dressings on the village green for centuries. Since 1897 Hartington Sports has run alongside the wakes with a Hartington Wakes Sports and Country Show which usually takes place on the second Saturday in September.

A Turbulent History

Not all the de Ferrers were royal favourites. In 1266 Henry's descendant Robert de Ferrers famously led a rebellion against Henry III. He was arrested and imprisoned, first in the Tower of London, then in Windsor Castle and Wallingford Castle. His lands and earldom were forfeited, including Hartington, which was given to the Earl of Lancaster. The busy market town remained in the Earldom (later the Duchy) of Lancaster for the next four centuries, during which time it expanded to separate into four quarters, each with independent administrations. The Town Quarter centre was around Hartington itself, while the Middle, Upper and Nether Quarters now lie within the parishes of Sterndale, Burbage and Biggin. These only became separate civil parishes in their own right in 1866.

The Roundheads pursued the Royalists into St Giles churchyard during the Civil War.

Just less than 400 years later Hartington was the site of further civil unrest. There were many skirmishes in this part of Derbyshire in the mid-seventeenth century between the Royalist Cavaliers and the Parliamentary Roundhead troops.

In June 1651 during the Civil War, a group of Royalists were surprised and defeated on Hartington Moor by Roundheads. Around 600 Royalists were slaughtered by Cromwell's men. Their bullets are still occasionally found on Hartington Moor. A few Royalists escaped and fled into the village, where the fighting continued in the churchyard, and some of them barricaded themselves inside the church. There is a barn in a lane nearby called 'Bloody Bones Barn' – a legacy of this battle.

The Loyal Cavalier
There is a tale about a man called William Rossington, a loyal Cavalier who fell on Hartington Moor during this same fray. His fiancée decided to rescue his body from the indignity that would be vented on it by the bloodthirsty Roundhead troops. She visited the battlefield and carried his body to Hedburn Wood near Cressbrook (approximately 10 miles away), where she buried the soldier. Despite a reward offered for his body, its location remained a secret. It was not until the 1830s that a farmer, installing a gatepost, finally discovered the remains complete with his warrior's helmet, sword, the buttons of his clothes and his armour.

Some Interesting Buildings

St Giles Church

The village was already well established by the time St Giles church was built during the late thirteenth, fourteenth and fifteenth centuries on a rise to the east of the Green. The size and stature of this building, which has seating for 400 worshippers, reflects the former status of the village. With an impressive west tower with battlements and crocketed pinnacles, it presents an imposing site. Perhaps the most interesting feature of its construction is the stonework which, in contrast to the limestone and gritstone buildings of the village, contains a high proportion of Staffordshire red sandstone. Mixed in with the Derbyshire limestone, and with gritstone detailing, this produces an interesting effect.

Hartington Hall

Apart from the church, the oldest buildings in the village date from the early years of the seventeenth century. Hartington Hall, which stands on the hill opposite the church on the road to Biggin, is probably the oldest complete surviving house, although a previous building existed upon the site. The earlier building was built around 1350 for the nuns of St Clair, while the present building was built by Thomas Bateman in 1611 and renovated by his descendants in the 1860s.

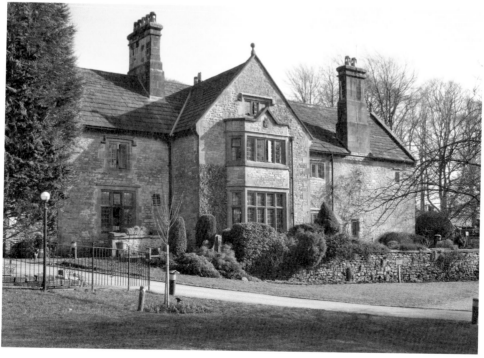

Since the 1930s Hartington Hall has been one of the county's most popular and historically interesting youth hostels. The bar and restaurant (stocking local ales and locally sourced produce) are open to the public.

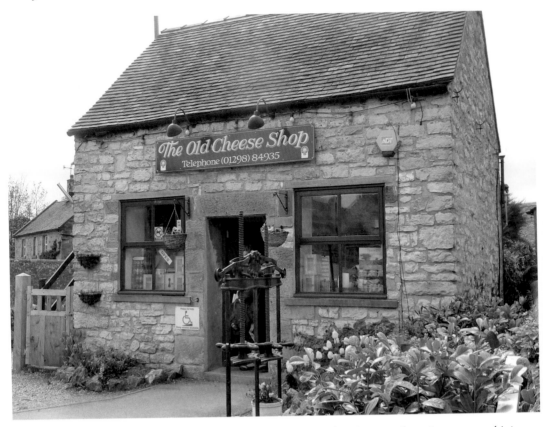

Nuttall's Creamery closed in 2009, but The Olde Cheese Shop (now under private ownership) still provides a retail outlet for locally produced cheese, including Hartington's world-renowned Blue Stilton, Buxton Blue and a variety of other fine, tasty cheeses.

It is a typical example of a three-gabled Derbyshire manor house built in the popular local style of the time with projecting side wings. The sides and rear were both added in 1861, together with the farm buildings. Bay windows were added to the ground and first floor on the west side in 1911.

According to tradition, Bonnie Prince Charlie stayed in a small dark room here after he marched his highlanders and supporters through Ashbourne in 1745 – on their ill-fated journey towards London (see Chapter 8). The small panelled room, where he is supposed to have slept during his subsequent retreat from Derby, still survives.

Around the Green and duck pond

In the eighteenth, nineteenth and early twentieth centuries, local trades people prospered in Hartington with its many businesses, including tailors and drapers, a number of coal merchants, blacksmith and wheelwright, saddler, vet, butcher and shoemaker. Their presence, and that of earlier traders, remains in the current array of cottages and retail establishments which surround the former market square, village green and duck pond in the centre of the village.

The Devonshire Influence and the Hartington Creamery

In the seventeenth century the Cavendish family bought the manor of Hartington. Since then the courtesy title of Marquis of Hartington has always been given to the Duke of Devonshire's oldest son.

In the 1870s the seventh Duke of Devonshire built a cheese factory on Mill Lane, so that his tenant farmers could better utilise their milk. This became known as the Hartington Creamery and was opened by the Duke in 1876, but the venture failed and the business was closed in 1895.

Thomas Nuttall then bought the site in 1900. Nuttall originally came from the Vale of Belvoir, the traditional home of Stilton cheese where it had been made for many years. Hartington Creamery became one of the three sources of Stilton, and also produced its own unique Dovedale cheese and others such as Buxton Blue, processing 50 gallons of milk a day. It had the distinction of achieving a Royal Warrant to supply Stilton to

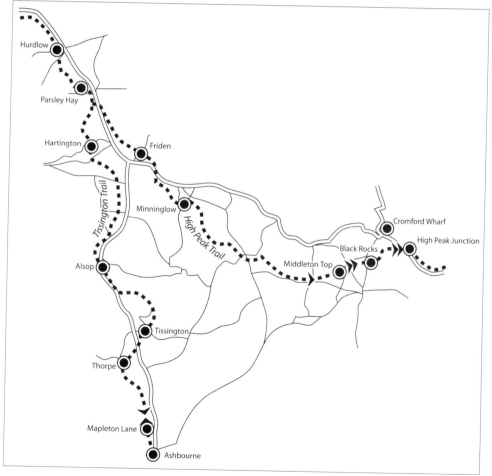

Today both the Tissington Trail (the former Buxton to Ashbourne railway line) and the High Peak Trail (formerly the Cromford & High Peak Railway) are popular with walkers and cyclists.

Along leafy Beresford Dale.

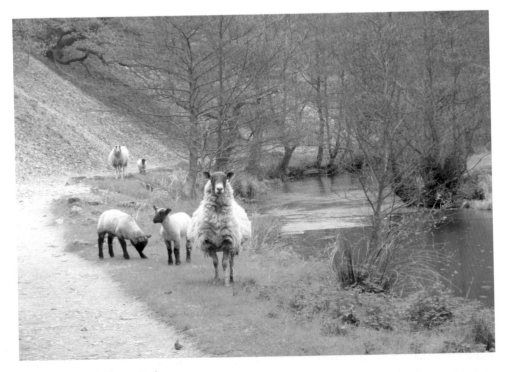

Springtime in Wolfscote Dale

George V in the 1920s and 1930s. (Legally Stilton cheese can only be made in the three shire counties of Derby, Nottingham and Leicester; had the factory been built a quarter of a mile to the west it would not have qualified, being outside the county boundary in Staffordshire.) Visitors flocked to the factory cheese shop in the village square, which became a mecca for all true cheese lovers.

The Railway

Unlike Longnor, Hartington was not neglected when the railways came to this area. The Buxton to Ashbourne railway was built by the London & North Western Railway at the end of the great age of railway building, opening in 1899. It utilised part of the Cromford & High Peak Railway line, a very early railway built between 1825 and 1830.

Passenger and goods services were run from 1899 until 1954. In its heyday, the line carried express trains from Manchester to London and until after the Second World War a daily train delivered milk from Peak District farms to Finsbury Park, London. Hartington was served by its very own station, although it was nearly 2 miles distant from the village, which was quite a long walk in the days when cars were a rarity.

Sadly, regular services ceased in 1954 and the line was closed in the 1960s. The National Parks Authority bought the Ashbourne to Buxton railway line in 1968. The track was converted into what is now known as the Tissington Trail, a popular cycle route and footpath which runs for 13 miles between Ashbourne and Parsley Hay.

Walking Beside the Dove

Between Hartington and the village of Ilam, 8 miles downstream, the Dove flows through Beresford Dale, Wolfscote Dale, Milldale and then Dovedale, cutting through a series of spectacular limestone gorges. Riverside paths make the whole route easily accessible to walkers.

Much of the dales are in the ownership of the National Trust, being part of their South Peak Estate. Dovedale itself was acquired in 1934, with successive properties being added, including Wolfscote Dale in 1948.

Beresford Dale and Wolfscote Dale on Foot

Beresford Dale is a narrow, well-wooded and beautiful part of the Dove Valley beside glistening waters which break over little weirs. The air is full of birdsong and wildflowers grow in profusion down to the water's edge. It is here that Cotton and Walton fished from their tiny fishing lodge and wrote *The Compleat Angler* together.

Wolfscote Dale is between the leafy wonderland of Beresford Dale and the much-visited Dovedale. Here the valley opens up temporarily into low-lying meadows, which give rise to wider views before the Dove resumes its progress through the limestone

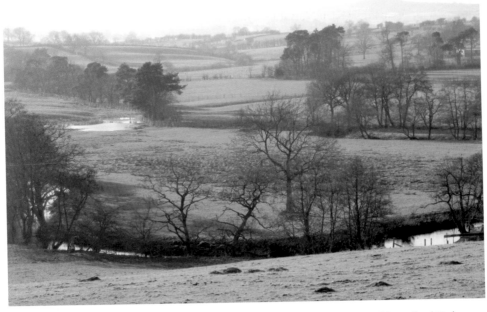

Above: A meander of the Dove from the footpath between Hartington and Beresford Dale.

Below left: Pike Pool.

VIATOR: What have we got there? A rock springing up in the middle of the river! This is one of the oddest sights that I ever saw?

PISCATOR: Why sir, from that pike, that you see standing up there from the rock, this is called Pike Pool; and young Mr Izaak Walton was so pleased with it, as to draw it in landscape in black and white. (*The Compleat Angler*)

Below right: Close to the bridge at Wolfscote Dale where, legend has it, the last wolf in the area was killed.

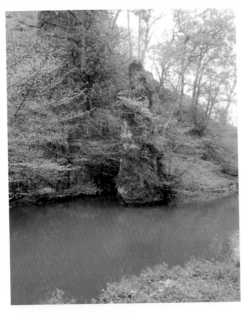

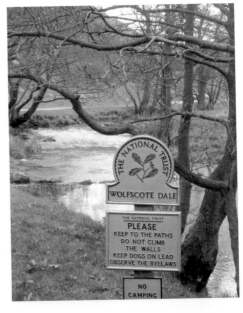

canyon into Dovedale. Legend has it that here, by a ford, the last wolf that roamed this area was killed.

To walk down both dales as far as Lode Mill at the southern end of Wolfscote Dale, and then retrace your steps, takes a couple of hours of easy walking. For a circular walk of two to three hours duration you can turn off into Biggin Dale and follow a dry path around Wolfscote Hill before taking a quiet lane which leads back into Hartington.

Directions

1. Parking is available in the centre of the village (on a quiet day) or in the car park opposite the public toilets on the Warslow Road on the outskirts of Hartington. The footpath leading down to the riverside dales begins with a gap in the wall clearly signposted 'Public Footpath to Dovedale ...' just behind the toilets.

2. Follow the footpath which passes first along the edge of the field behind the houses. Pass through two small gates to cross a footpath, then follow the track across a field. Follow the yellow arrows, sticking to the footpath (which can get very muddy at times) as you gradually descend towards the River Dove. Just before you enter a wooded area you may be able to catch a glimpse of Cotton and Walton's Fishing Temple (which still stands in a corner of private grounds by the river) in the trees down the hill to the right.

3. Pass through the gate in the wall into Morson Wood, then follow the path to the river. Cross over the bridge to the Staffordshire side where you will find Pike Pool, so called due to the discourse between Viator and Piscator in

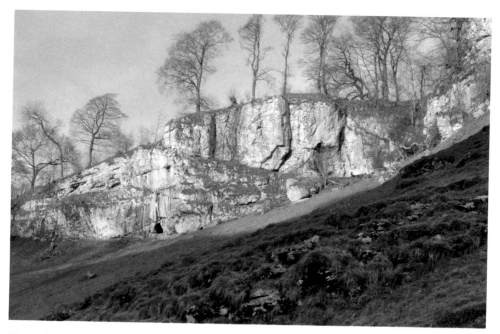

Trees cling to tors, and semi-alpine plants and flowers cling to crevices in the cave-pocked limestone crags on either side of Wolfscote Dale.

The many small weirs along the rivers were built to increase the feeding area for trout, and so improve the fishing.

The Compleat Angler about the jagged rock 'in the fashion of a spire steeple and almost as big' that sticks out of the pool here. This rocky, enclosed and picturesque stretch of the river was possibly Walton's favourite. The west bank above Pike Pool has several limestone crags and caves hidden behind a high wall (now private ground). It is here that Cotton reputedly hid from his debtors who pursued him relentlessly throughout the course of his life.

4. Follow the path to a footbridge at the end of a single track road which comes down to the river here, then cross the river again.
5. Follow the path across the meadow (or if it is wet and muddy, you may prefer to follow the higher track which runs alongside the wall) towards the twin crags known as the Celestial Twins, which loom over the next bend in the river.
6. You will come to the bridge which marks the boundary between Beresford Dale and Wolfscote Dale. Do not cross this bridge but stay on the east bank and pass through a small gate to enter Wolfscote Dale.
7. The valley now resumes its progress through the limestone canyon. Follow the clear path along the east bank below massive pinnacles and outcrops of rock topped by sparse tree coverage.
8. Continue for about 2 km of beautiful riverside scenery. Long screes scar the hillside increasingly as you approach the rock cliffs of Drabber Tor on the opposite bank.
9. Opposite the rocks you will come across a large signpost offering the choice of turning left into Biggin Dale (to pursue a circular route back to Hartington) or continuing alongside the river (signposted Milldale) to the end of Wolfscote Dale at Lode Mill (a distance of approximately 2 km) before retracing your steps back along the Dove.

If you opt for the circular route, follow the directions from point 13 onwards.

Continuing along the Dove to Lode Mill

10. Continue along the river in the direction of Milldale. The path clings closely to the bank as the river zigzags along, tumbling over a series of small weirs, past Coldeaton bridge.
11. You will finally arrive at Lode Mill where a single arched road bridge crosses the river. This is the first road bridge since Hartington. The bridge is of nineteenth-century construction. Previously the river was forded at this point and in 1658 a woman drowned here attempting to cross.
12. To return to Hartington simply retrace your steps from Lode Mill back along the river.

Along Biggin Dale back to Hartington

13. Follow the signpost into Biggin Dale and continue up the usually dry path towards the head of the dale.
14. Pass through a gate, then follow the path alongside the wall to the point where it branches, close to a dewpond behind the wall. Take the left fork (signposted Hartington) and follow the path through a gate in the drystone wall.

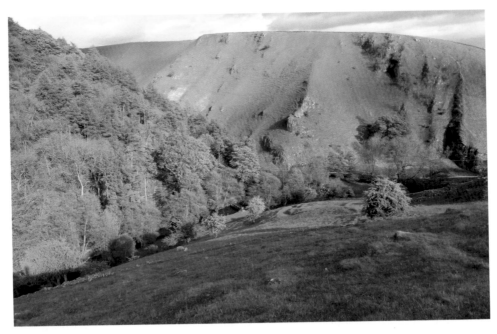

Iron Tors looms above the Dove as she winds on towards Lode Mill.

15. Continue following the path as it winds uphill, following the signposts for Hartington.

 After what can be a long and muddy trail, you will eventually meet the road. Follow the road straight on towards Hartington. You will enjoy some fine views of the rooftops as you drop down into the village.

16. A path on your left as you approach the village will lead you down a field to the back of the houses. Following the path right behind the houses will bring you out in the village close to your starting point.

From Lode Mill a quiet side road follows the Dove.

Chapter 5
Milldale, then along Dovedale

Easily the best known of the dales of the Dove Valley, Dovedale has been attracting visitors for centuries. Eighteenth- and nineteenth-century travel writers in particular couldn't praise it highly enough, devoting pages to expounding the virtues of the dale and paying tribute to its picturesque attributes. 'Nothing,' wrote Sir Richard Phillips (1767–1840), editor of the *Monthly Magazine*, 'can be conceived more picturesque, astonishing, and even sublime; and a visit will repay every traveller and lover of nature, in its rude and grand features'.[5]

'It is perhaps,' observes Gilpin in his *Northern Tour* (1834), 'one of the most pleasing pieces of scenery of the kind we anywhere meet with … Its detached perpendicular rocks stamp it with an image entirely its own; and for that reason it affords the greatest pleasure.'

Watercolour artist Edward Dayes (1763–1804) claimed that

it possesses an union of grandeur and beauty, not to be equalled by anything I ever beheld … here beauty reigns triumphant … Happy is the man who, divested of care, finds himself enabled to retire to such scenes as these and who, at the same time, possesses sensibility to enjoy their excellence.[6]

Today, even accounting for the hyperbole of these early travel writers, Dovedale still has the power to astonish and rarely fails to disappoint.

This chapter begins with a look at the tiny but picturesque village of Milldale, the starting point for a stroll down Dovedale in a southerly direction. Crossing over the famous Viator Bridge, it then provides a detailed guide to this most famous 2½-mile walk with its imaginatively named rock formations, caves and associated characters and folk tales that have been delighting writers, artists and tourists for centuries.

Milldale

Milldale consists of just about a dozen square stone cottages, mostly eighteenth- and nineteenth-century (but some dating back to the seventeenth century) clustered right

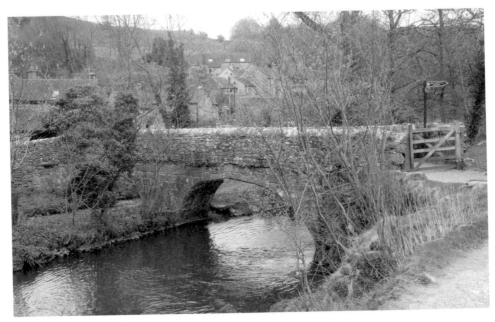

Viator Bridge appeared quite frightening to the fictional Viator:
'What's here, the sign of a bridge? Do you travel in wheelbarrows in this country? This bridge was made for nothing else – why a mouse can hardly go over it, tis not two fingers broad!'
(Viator in Cotton's addendum to the 1676 edition of *The Compleat Angler*)[1]

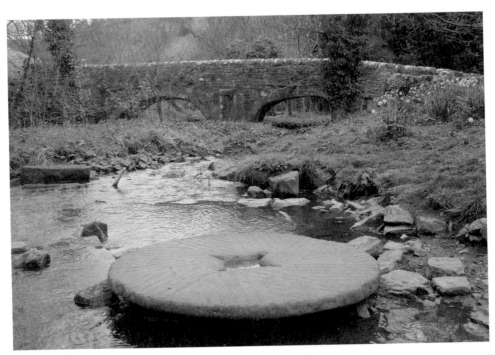

On the village side of the bridge, this millstone, lying by the river bank, provides evidence of earlier industry in the village – as does the weir to raise the water level and direct the flow to a mill race and wheel.

Outside an Information Barn is the pool where farmers used to wash their sheep in the river prior to shearing (as portrayed by this carving inside the barn). This practice was only abandoned here in 1965.

on the edge of the Dove. It is most famous for its ancient packhorse bridge, known as Viator's Bridge. Today this is crossed on a fine day in summer by literally hundreds of walkers. Many call it the most famous bridge in the whole of the Peak District.

Viator's Bridge

The bridge was made famous by Charles Cotton in his addition to the fifth edition of Walton's *The Compleat Angler*. Then, the narrow bridge would have had no walls. Bridges were designed simply with low parapets to allow pannier-bearing horses to cross without obstruction.

Industry

There was a corn mill which used to stand close to Viator's Bridge from which the village's name derived. The mill was demolished in the mid-nineteenth century but the foundations are still visible by the river. The wheel in the river wasn't used to grind corn, however. It crushed calamine which was processed in a second nearby mill which was powered by water diverted from the River Dove in a channel. The calamine was mined at Chrome and Parkhouse hills just south of Buxton (see Chapter 3). Drug firms used the higher-quality calamine, and lower grades were used in brass making. In the nineteenth century, it was used to grind colours for paints.

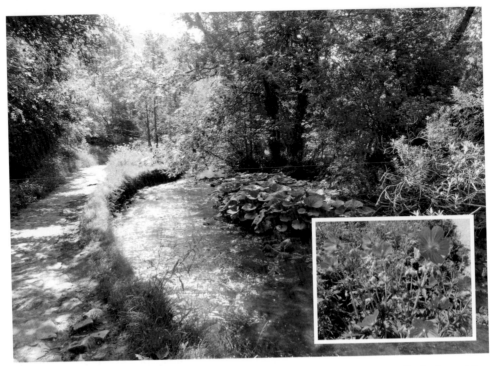

In the summer months the path alongside the trickling waters of the Dove is flanked on either side by a profusion of wild flowers with buzzing insects.

The Grand Old Woman of Dovedale

Annie Bennington used to be a familiar figure to visitors passing through Milldale in the first half of the twentieth century. She would linger by the bridge and, when she saw walkers approaching, would rush to the gate and hold it open for the visitors, holding out her hand for a tip. She eventually set up a stall by the bridge selling mineral waters, sweets and postcards. (In her younger days she had operated this business from Reynard's Cave, down the valley, but the steep climb and 3-mile round trip led to her relocating it in her later life.)

Along Dovedale – That Famous 2½-Mile Walk

As discussed at the beginning of this chapter, travel writers have been describing the walk through this limestone gorge, along the banks of the Dove, for centuries. *Bemrose's Guide to Derbyshire*, published in 1869, advises us that then, just as today, 'travellers generally prefer the upward route [i.e. walking upstream from the southern entrance], but it is equally spectacular in either direction'.[6]

This walk follows the river downstream from Viator's Bridge. It takes about two and a half hours to walk from Milldale down the eastern (Derbyshire) bank of the Dove to the stepping stones beneath Thorpe Cloud and back again. It is an easy walk with only one stepped climb.

Directions

1. From the village of Milldale cross Viator's Bridge, then turn right to enter Dovedale. The walk begins gently through open meadows and grassy slopes.

2. Pass through a gate then shortly afterwards a second one to enter the deep limestone gorge. Follow the gravelly path alongside the river.

3. After about half a kilometre you will come to the first of Dovedale's many limestone showpieces. As James Croston explains in his 1862 guide *On Foot Through the Peak*, 'each particular rock has been named by the neighbouring peasantry or guides'[7]. Raven's Tor, a great buttress, rises sheer above the Staffordshire bank.

4. Continue along the path past flower-rich meadows which, in summer, completely obliterate the signposted path to Alsop en le Dale on your left. Soon after the path enters a more heavily wooded area, you will come to the most spectacular of the many caves and arches formed by underground streams. The two huge gaping eyes on your left are the Dove Holes.

5. Continue along the now-wooded gorge, rich with foliage on either side of the path until you come to a small wooden bridge which crosses the river, behind which looms the spectacular Ilam Rock, a single, lichen-covered monolith rising tall, sheer and slightly tilted from the water's edge on the Staffordshire bank. A little further downstream on the left-hand (Derbyshire) bank are the great blocks of Pickering Tor, another rock formation which became increasingly popular with artists. Crossing the bridge at Ilam Rock would take you into Hall Dale, a side valley which winds its way up to the hamlet of Stansthorpe. The southern side of the dale is covered by Hurts Wood, one of the most thickly wooded areas of the gorge. The northern slope of Hall Dale, known as the Greek Temple, is comparatively bare, grass covered and only slightly wooded.

6. Do not cross the bridge but continue along the path on the Derbyshire bank, where you will soon see a massive crag known as Lion's Head Rock projecting over the path. High on the bank above Lion's Head Rock is a much smaller block, the Watch Tower, which has every appearance of being about to slither down into the river.

7. Continue along the path underneath Lion's Head Rock. After about half a kilometre the dale narrows and meanders, becoming more like a gorge. Hobson describes the change in his *History of Ashborne*, published in the mid-nineteenth century: 'two stupendous cliffs ... rise abruptly on either side of the river. The chasm here is so narrow that, when by heavy rains the stream is swollen, the passage through it becomes impractable.'[6] This part of the river is known as The Straits and today the path is artificially raised in order to bring it above the water level.

8. On leaving the path over The Straits, you will soon see a path to your left. This leads up to a massive arch of rock with a narrow crevice in its top, from which a bush sprouts (more easily seen if you are travelling in the opposite direction towards Milldale). This was the mouth of Reynard's Cavern until the roof fell in, the cave now being located part way up the side of the valley. It is named after a local brigand who made the cave his refuge. He was probably one of many who have used the cave for shelter or as a refuge over the centuries. Bronze Age relics

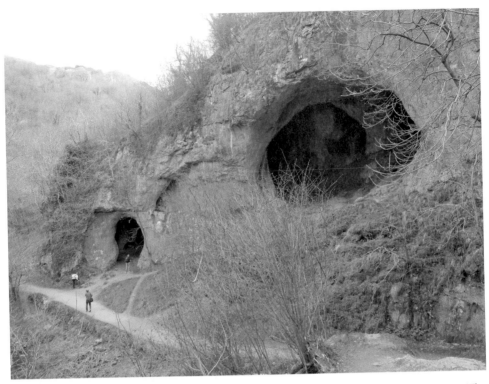

The Dove Holes are two impressive caves created by water wearing out the soft limestone. The larger of the caves is some 60 feet wide and 30 feet high.

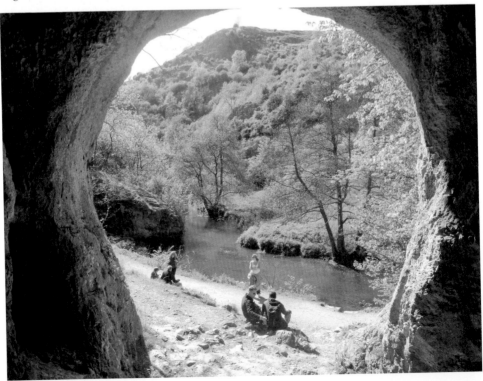

'Shepherd's Abbey' stands on the Staffordshire bank, opposite.

found in the cave are kept at Buxton Museum and Art Gallery. There is a smaller cave to the left, known as Reynard's Kitchen. The cave is most famous for a tragic and fatal accident that took place when Dean Langton (chaplain to the third Duke of Devonshire) attempted to scale an incline close to the cave. There are many elaborations on the tale as to how it came about but this account from a journal of that time seems a fairly reliable one:

In July 1761, Mr Langton (then Dean of Clogher) being on a visit at Longford Hall ... formed one of a party to visit Dove-Dale. After viewing the scenery and partaking of refreshment in a spot near Reynard's Cave, they prepared to return, by way of Tissington, it is supposed, for the Dean proposed to ascend on horseback a steep hill, over a path led to that village; and Miss La Roche, a young lady of the party, agreed to accompany him on the same horse. Mistaking the road, the Dean unfortunately followed a sheep-track on the right of the eminence, which he found too steep to ascend; in attempting to turn about the horse, overpowered by the burden imposed upon him, fell backward down the hill. The Dean being precipitated to the bottom, was taken up so dreadfully

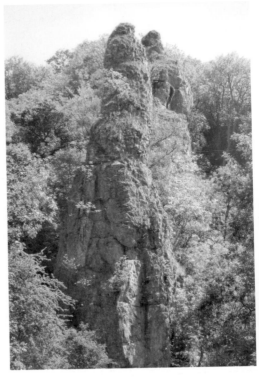

Above, left and right: Ilam Rock, Pickering Tor.

Left: Lion's Head Rock is named due its likeness to the king of the beasts, though in this early spring picture his mane has yet to develop to its full extent.

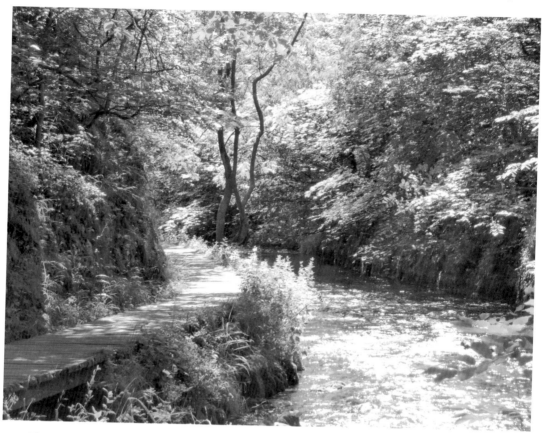

The Straits.

bruised, that he died within a few days and was buried in Ashborne church. Miss la Roche, whose fall was broken by her hair becoming entangled in a thorn bush, escaped with some severe contusions, though for two days she continued insensible. The horse, more fortunate than his riders, was slightly injured.[6]

9. Moving on, the Dove continues in a varied succession of still waters, rapid streams and small cascades. On the Derbyshire bank you will pass some 'coin logs', shortly followed by an old pump station, originally used to pump water from the Dove onto farmland above. Look out for the rock formations known as Dovedale church on the Staffordshire bank and Tissington Spires looming up on the Derbyshire side.

10. A little further along the Stafforshire side, 'The Twelve Apostles' reach up, through a rich foliage of mountain ash, hazel, hawthorn and a variety of flowering shrubs.

11. More or less opposite, a short stepped climb begins through mature woodland to a round elevation covered with smooth and flowery turf which overhangs the river and forms a popular picnic spot and viewpoint. Close by a set of steps climb to a limestone promontory known as Lovers' Leap. The original steps were apparently built by Italian prisoners of war captured in the Second

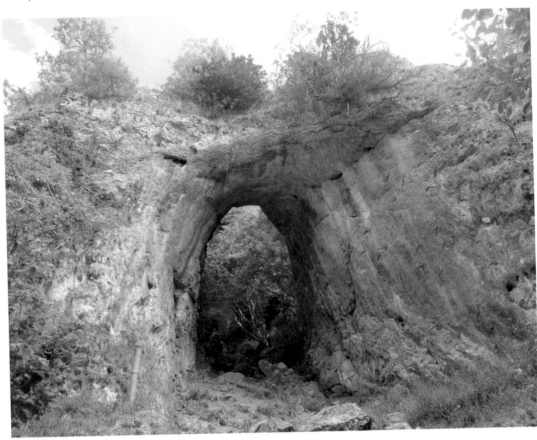

The climb up to Reynard's Cave can be slippery, but it is worth making the effort for the remarkable view from the other side through the arched entranceway, which stands covered in ivy and trees that have clung onto these cliffs for hundreds of years.

World War. The steps are now maintained by both the National Trust and the Peak National Park. Another tale associated with Dovedale is that of a young woman who this time flung herself from the top of this limestone promontory thinking that her lover had been killed in the Napoleonic War. (There are actually several versions of which war it was, some even saying the Second World War, but this is the most popular.) Just like Miss la Roche at Reynard's Cave, however, it would seem that fate or the gods intervened. This time it was the lady's flapping skirt that got caught on the branches of a handily placed tree, breaking her fall and saving her life. This tale (or most versions of it) ends happily, as when she returned home, feeling rather foolish, no doubt, she discovered to her great joy that her lover was, in fact, alive and well.

12. Now you come to the final stretch of Dovedale, soon approaching a large bend in the river beyond which the famous stepping stones lie. In the next chapter you will turn off just before the stepping stones to climb Thorpe Cloud and Bunster Hill and enjoy the lofty views down Dovedale.

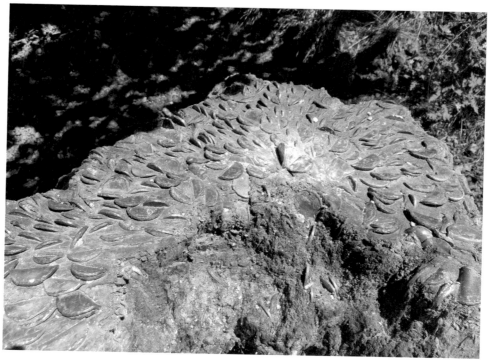

Low-value coins have been hammered into these coin logs and stumps in some interesting patterns.

The large mass of rifted rock on the left, indented with deep cavities and fissures, is known as Dovedale church, while the great limestone pinnacles shown on the right and on the Derbyshire bank are the Tissington Spires.

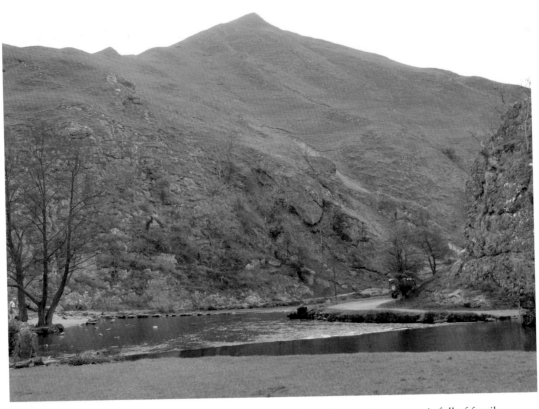

The huge reef knoll of Thorpe Cloud, which towers above the stepping stones, is full of fossils.

13. For now, however, cross the Dove by the stepping stones and continue on the right (the Staffordshire) side of the river.

When the Dove is in flood the stones are closed. If this is the case, or you would rather not cross over them, simply continue down the Derbyshire bank for a short distance and you will come to a wooden footbridge across to the Staffordshire side. It is then only a short stroll to the car park at the southern end of Dovedale, where you can get welcome refreshments before beginning your return journey.

An Inspirational Setting

Today the dale provides an inspirational setting not only for poems and books but for films and television too. This area along the river was used in Franco Zeffirelli's 1996 version and the BBC's 2006 version of *Jane Eyre*. Dovedale was featured on the 2005 BBC television programme *Seven Natural Wonders* as one of the wonders of the Midlands. Most recently, parts of the 2009 *Robin Hood* film were filmed not, as you might expect, in Sherwood Forest but along Dovedale.

Plant and Animal Life in Dovedale

Recognising the conservation value of the Dove Valley, the National Trust acquired the South Peak Estate in 1934, much of which lies in Dovedale and neighbouring Wolfscote Dale. The whole dale system is now a Site of Special Scientific Interest (SSSI) for its geology, flora and fauna. The habitats below are of particular interest.

Ancient Woodlands
Woodland is the natural vegetation of Dovedale, dominated by ash and wych elm. Ancient woodlands like these have much more wildlife value than newer woodland or plantations. They support a variety of woodland flowers, some unusual, including the slender Solomon's seal, delicate Lily of the Valley, Wood Avens, and Paris quadrifolia.

In clearings, especially, shrubs such as ash hazel, gelder rose and the rare mountain currant can be found. The diversity of plant life in turn supports many different types of wildlife. Where parts of the wood have been traditionally coppiced, a habitat which is particularly good for small birds and mammals, such as the common shrew, is provided.

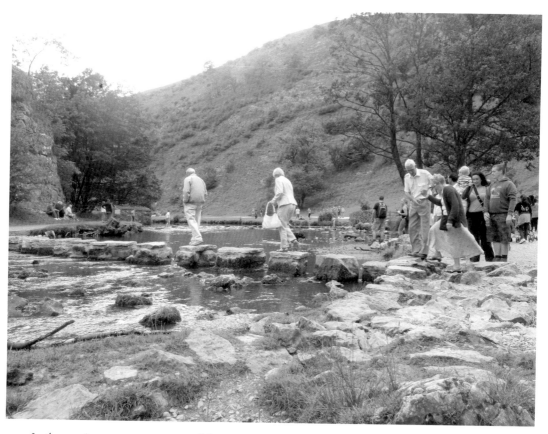

In the tourist season, you may well have to wait to cross the stones.

The well-oxygenated waters provide food for a multitude of water birds along the banks of the river.

Rocks and Screes

The effects of frost on the cliffs and screes above Dovedale and Wolfscote Dale have helped shape the development of specialised flora, such as mosses, lichens and flowers.

Limestone Grassland

Many years of grazing by sheep, cattle and rabbits have created extensive areas of flower-rich limestone grassland along the steep sides of the dales where the scree has stopped moving. These grasslands contain an enormous diversity of wild flowers, including thyme and rock rose and their associated insect life such as the common blue butterfly. The National Trust have cut back shrubs and reintroduced sheep grazing in some areas where famous rock features were becoming hidden.

The Waters and Banks of the River

Today the water is clean and well oxygenated so it supports many invertebrates such as stoneflies, crayfish and freshwater shrimps. These in turn provide food for the multitude of wildlife along the banks of the river. Dippers are a common site, dashing up and down the river, as are herons often seen feeding, particularly in the quieter northern stretches. Grey wagtails, moorhens and water voles are common, and you might also see the occasional kingfisher.

The National Trust works together with tenant farmers to ensure the preservation of this rich diversity for the future.

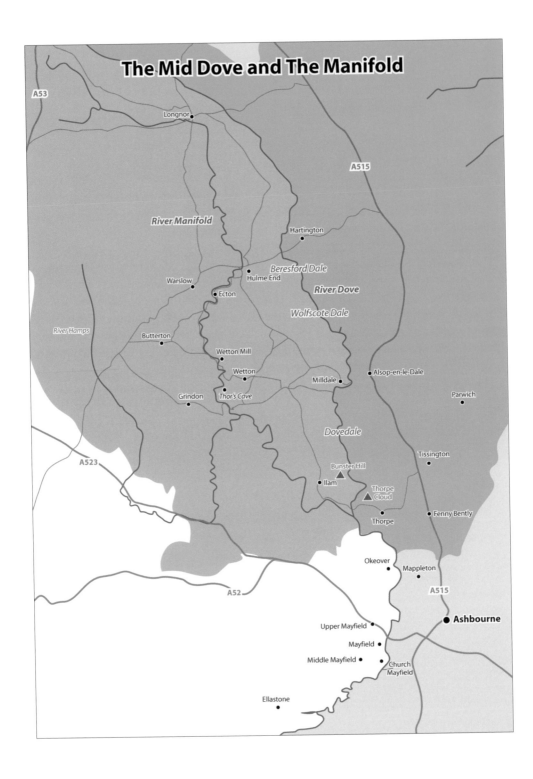

The Mid Dove and The Manifold

A53

A515

Longnor

River Manifold

Hartington

Beresford Dale

Warslow

Hulme End

River Dove

Ecton

Wolfscote Dale

River Hamps

Butterton

Wetton Mill

Wetton

Milldale

Alsop-en-le-Dale

Grindon

Thor's Cave

Parwich

Dovedale

A523

Tissington

Bunster Hill

Ilam

Thorpe Cloud

Fenny Bently

Thorpe

Okeover

Mappleton

A52

A515

Upper Mayfield

Mayfield

Ashbourne

Middle Mayfield

Church Mayfield

Ellastone

Chapter 6
Two Hills, Thorpe, Ilam Village and Park

When nineteenth-century travel writer James Croston journeyed through Derbyshire, he approached Dovedale, like many other walkers, from its southern entrance flanked by its two mighty hills: 'Bunster Hill, on one side, and Thorpe-cloud on the other – two abrupt and lofty eminences … like mighty sentinels guarding the approach to this narrow and gloomy ravine'.[7] These guardians to Dovedale are easy to access and present not too difficult a climb, which is well worthwhile for the spectacular views (especially of each other) from their summits.

This chapter begins with a scramble up Thorpe Cloud and Bunster Hill before moving on to the villages of Thorpe and Ilam. A short and easy walk around Ilam Country Park is recommended, which takes in many of the highlights of this beautiful estate.

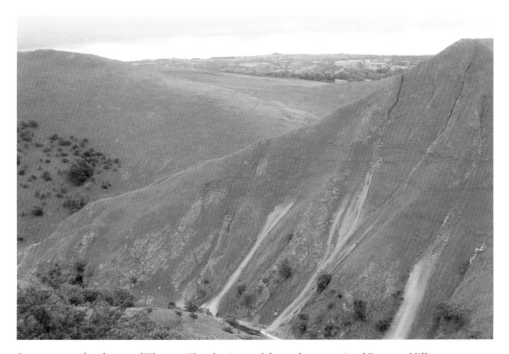

Scree covers the slopes of Thorpe Cloud (pictured from the summit of Bunster Hill).

Thorpe Cloud

The conical 1,000-foot limestone hill Thorpe Cloud has been capturing the imagination of writers and landscape artists for centuries.

Thorpe Cloud looks rather like a volcano with a flat top but in reality it is a 'mud mound', formed under the tropical sea which covered the area 350 million years ago. The Carboniferous limestone of this amazing hill is full of fossils from the sea of that time. Its slopes are covered with loose stones, called 'scree', rock that has been weathered by freezing and thawing.

The rather romantic-sounding name of the hill is easily and rather disappointingly explained. Thorpe is a farm or hamlet in Danish, the village above which the hill towers being originally a ninth-century Danish settlement. 'Cloud' has its roots in the old English word 'clud', meaning large rock or hill. So Thorpe Cloud simply means 'The hill by the Danish farm'. There is nothing disappointing, however, in the views that result from the short and popular climb to its summit.

Climbing Thorpe Cloud
The path up to the summit of Thorpe Cloud starts close to the famous stepping stones. It is a short but fairly challenging climb and takes about an hour to ascend, scramble down the other side and return to your starting point.

The top of Thorpe Cloud can be a windy place, but has some fine views, including the Izaak Walton Hotel, Ilam village and Ilam Hall and Country Park to the west.

The picturesque, seventeenth-century Izaak Walton Hotel has played host to many famous guests. Alfred Lord Tennyson (1809–1902) signed the visitors' book recording his opinion of its location as being 'one of the most unique and delicious places in England'.

The path climbs over rocky steps before reaching a more defined path above Lin Dale. As you gain height the views open up. Looking north, back the way you have come, you will get some fine views along the River Dove. Looking west, Bunster Hill looms. More rocky steps take you to the small summit ridge. The views from here are even more impressive. To the north, on a clear day, St Peter's church at Alstonefield can be seen and to the west, the Izaak Walton Hotel and Ilam Hall.

The way down the other side of the hill is less clearly defined, with a rather steep descent down a grassy slope. After what can be a scramble, you soon pick up the path that leads back to the riverside, taking you around the base of the hill to the bridge just before the car park at the Thorpe end of Dovedale. Following the riverside path will soon bring you back to the stepping stones at the start.[8]

Climbing Bunster Hill

Bunster Hill is a less steep climb than Thorpe Cloud. Once you are up there, it has a broad ridge from which there are stunning views across Dovedale, Ilam and the surrounding area. The ascent of this hill begins behind the Izaak Walton Hotel. If you park in the car park at the southern end of Dovedale, a footpath beginning just outside the entrance will take you to the hotel. The path behind the hotel crosses farmland before heading right, up onto the ridge of Bunster Hill. It involves one short scramble and passes through a few gates and stiles, but the views from the top of the ridge will more than reward your efforts.[7]

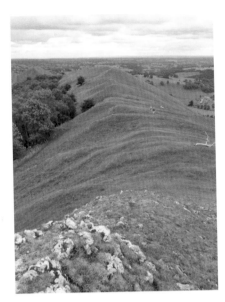

Above, left and right: A walk across farmland, followed by a short scramble will take you on to the broad ridge of Bunster Hill.

The pretty village of Thorpe, viewed from St Leonard's churchyard.

St Leonard's church in Thorpe has a squat Norman tower and a Norman nave. Its font is eleventh-century and is one of only three Derbyshire 'tub' fonts.

From here you have a choice. You can retrace your steps back to the car park from where you can begin your exploration of the villages of Thorpe and Ilam, and Ilam Country Park. Alternatively, and for a slightly longer circular walk (about 4 km in total), you can take the gate into Dovedale Woods on the left of the ridge. Following a narrow but clear path down through the woods (taking the right-hand path where the path splits) will eventually bring you out by the River Dove close to the bridge at Ilam Rock. Cross the bridge and turn right to follow the riverside footpath back to the car park at the start of your walk.

Thorpe Village

Sir Bernard Burke wrote enthusiastically about the countryside of this area in the mid-nineteenth century:

> The hills about Ilam have a magnificent and almost sublime character. They are thrown together in irregular masses, which, with one exception only, are connected. Some of them are covered with noble woods, while others again present to the eye a carpet of the smoothest and most glossy verdure.[8]

This image of a verdant green land is repeated by James Croston, who, during his journey from Ashbourne to reach the southern end of Dovedale in 1862, wrote delightedly of 'the green pastures, the sunny glades, the fine and fertile meadows, the slopes mantled with waving woods'.[7]

The warm, rich landscape surrounding the villages of Thorpe and Ilam, and further south towards Ashbourne, Mappleton and the Mayfields, still answers this description perfectly today. Thorpe village itself, dominated by its conical hill, is a quiet and pretty village with stone cottages and a few more affluent homesteads. Originally a Danish settlement from the ninth century, it is mentioned in the Domesday Book – a 'thorpe', as previously mentioned, being a farm or hamlet in Danish.

Its most distinguishing feature, apart from its startling hill, is its church. St Leonard's is predominantly Norman with some Saxon items. By the south porch you can see some interesting scratch marks on either side of the doorway. This is where arrows were sharpened in the fourteenth century. The Black Death had so severely reduced the number of available archers (essential to protect the King and country) that a decree was passed that every Englishman must set aside Sunday afternoon for archery practice. Nowadays, there are no shops or pubs in Thorpe, just peace and quiet and some lovely views.

The Ilam Estate

Burke was equally eloquent about the Ilam Estate:

> In the space between them [the hills] lies the lovely vale of Ilam – so lovely, indeed, that the tourist can hardly be accused of exaggeration when he exclaims in a burst of irrepressible enthusiasm:–

James Trubshaw, the designer of Ilam Hall (pictured), was also engaged in the building of Alton Towers. With its battlemented towers, ornamental chimneys and a flag tower, there are some similarities between the two.

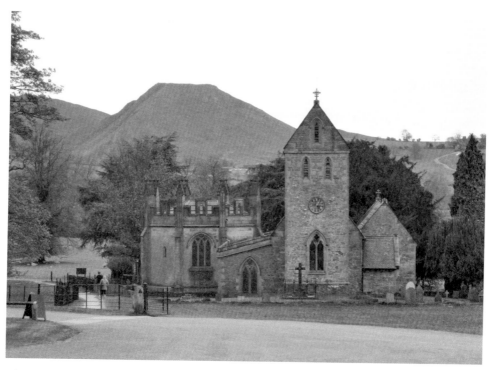

The ancient Church of the Holy Cross (seen here with Thorpe Cloud behind) remained close to the hall, but has been rebuilt and extended several times in its history.

> I felt as if I had been treading on fairy-ground, the parts were so beautiful and so exquisitely combined, and the whole so rare and unexpected, that it seemed more like a scene of enchantment that might soon pass away, than anything real and permanent. A village of a few houses only scattered among the trees, verdant meadows watered by a busy stream everywhere sparkling with light, and on a gentle eminence.[8]

One of the most distinctive and spectacularly located villages in this area of the Peak, Ilam also has one of the longest histories.

History of the Ilam Estate

The Ilam Estate was the property of Burton Abbey until the dissolution of the monasteries (1538–41) by Henry VIII, after which it was given to the Port family. They lived at Ilam Hall, which was a rather more modest building at that time, until the early 1800s. In 1809 the Ports sold the estate to Jesse Watts-Russell and his wife Mary, the daughter and heiress of David Pike Watts.

Jesse embarked on changes to the whole estate. He hired renowned architect of the time James Trubshaw to design a new hall. Together they completely rebuilt Ilam Hall on a much larger scale. It was greatly admired at the time by its many visitors.

Jesse is also responsible for the distinctive look and location of today's village. The current village was moved in the 1820s from its position near Ilam Hall and rebuilt in what he considered to be an 'Alpine' style. This explains both the unusual style of the

Ilam Bridge takes visitors into the heart of the village, dominated by its memorial cross.

buildings and also the surprising distance between them and the village church, the ancient 'church of the Holy Cross', located close to the hall.

Several more buildings in different styles were also added to the village. A new school building replaced two earlier small schools, together with a black and white house built for the schoolmaster. The vicarage was also rebuilt. It is now known as Dovedale House and has become a residential youth centre used by many schools and church groups. A new road and bridge were built to take traffic further away from the hall.

In 1840 Jesse's wife Mary died at the early age of forty-eight, plunging Jesse and their eight children into grief. Jesse asked Oxford-based architect John Macduff Derick to design a memorial cross to commemorate his wife, which was erected close to Ilam Bridge. Derick's design is six-sided in plan and incorporates large niches containing six saintly statues of female allegorical figures or 'angels'. Jesse also wanted the monument to include basins fed with pure spring water for the use of the villagers, pure water being another resonant religious symbol.

The epitaph on the monument reads:

> This Cross and Fountain
> erected by her husband
> perpetuate the memory of
> one who lives on in the hearts
> of many in this village and
> neighbourhood

Mary Watts-Russell
MDCCCXL

Free for all these crystal waters flow
Her gentle eyes could weep for othere' woe;
Dried is that fount; but long may this endure,
To be a Well of Comfort to the Poor

Soon after Jesse's death in 1875 the family sold the estate to another industrialist, Robert William Hanbury – a coal miner and politician. He continued the improvement of the village, but after his death in 1903 his widow remarried and eventually the estate was sold again to a Mr Blackhouse. He tried to turn the hall into a profitable concern, converting it into a hotel including a restaurant and golf course. The venture failed and in the 1930s he sold off the hall to a demolition company. Two thirds of the hall was demolished and the stone sold as building material before Sir Robert McDougall (the flour magnate) stepped in to save the building. He bought what was left and gave it to the Youth Hostels Association 'for the perpetual use of the youth of the world'. As the YHA did not have a trust body, it gave the building to the National Trust. What remains today are the old entrance hall, armoury and servants' quarters, which have been converted into the Youth Hostel. There are also tea rooms, a shop, information facilities and a car park available for the use of the general public.

Above left: The pepperpot dovecote is a short distance from the Church of the Holy Cross.

Above right and next page above: The elaborately carved Saxon font and St Bertram's tomb at Ilam's Church of the Holy Cross.

Left: In the churchyard this beautifully carved monk's stone dates from the thirteenth century.

A Short Stroll Around Ilam Country Park

Ilam Country Park is a beautiful open space at the south end of the Manifold Valley, designed in the nineteenth century as an idyllic setting for Ilam Hall. This short stroll begins at the car park within the park (£2 at the time of writing) and takes about an hour of easy walking. It takes in a visit to the small but beautiful church of the Holy Cross containing the tomb of St Bertram. The church is well worth spending some time exploring before wandering down to Bertram's Bridge. From here you can stroll along the Manifold, past the boil holes where the Manifold resurges from her underground journey, then along the aptly named Paradise Walk. It ends at the tea room, close to the shop and information centre next to the car park where you began.

Directions
1. After parking your car, walk back to the car park entrance. Notice the aptly named ornate dovecote the 'pepperpot' on your right-hand side.
2. From here, take the small footpath opposite the entrance to the car park which leads down to the Church of the Holy Cross. *(Continued on page 91)*

The Church of the Holy Cross

There has been a church in this location since Saxon times, but all that remains of the original building is some masonry in the south wall and a blocked doorway, visible from outside between the two nave windows. However, the two Saxon crosses in the

Leading local craftsmen produced the ornate interior. The chancel tiles are Minton; the etched and painted glass in the 'plain' windows is by Powell (1856); and Gilbert Scott added several stained-glass windows.

It is thought that these may be the garlands used at the funerals of Hannah Ditchfield (1834) and Sarah Rowbottom (1861).

churchyard date from the early period, as do (inside the church) the carved font and tomb of St Bertram, with whom the church is associated.

St Bertram

Local tradition says Bertram was a king of Mercia around the eighth century. Thinking he might have a religious calling, he travelled to Ireland, where saints such as Patrick and Columba had lived. While he was in Ireland he fell in love and eloped with a beautiful princess. He brought her back to Mercia, travelling while she was pregnant. They lived a nomadic life and it is thought that the baby was born in the shelter of the forest near Stafford. But while Bertram was away hunting for food in the forest, tragedy struck. Wolves came and killed his wife and child.

Overcome with grief, Bertram renounced his royal heritage and turned once again to God. He sought a life of prayer and lived as a hermit in the Stafford area and later near Ilam (in the woods on the other side of the river) for the rest of his life. He became known in the area as a wise and holy man, whom people sought for spiritual advice and devoted his life to healing the sick and converting them to Christianity. It is said that many pagans were converted to Christianity by the example of his life.

Over the centuries pilgrims have travelled here from far and wide to lie on top of and crawl through the side of the shrine to his memory in the hope of a cure for their illnesses.

St Bertram's Well is said to have provided fresh water since Saxon times.

The church has been restored and extended a number of times during its history. The Burton Abbey monks rebuilt and enlarged the small Saxon church and added the tower. The altar tomb over St Bertram's coffin was built at that time. The church was further modified in the seventeenth century by the Meverell family of Throwley Hall (now in a ruinous state on the opposite bank of the river and north-west of Ilam). They built St Bertram's Chapel in 1618 to house the Saint Bertram tomb. The Meverell family tomb is also in the chapel, almost hidden by the organ.

In 1831 an imposing mausoleum chapel, the Chantrey Chapel, was added on the north side of the church by Jesse Watts-Russell as a burial place for his family. It houses the Pike Watts monument – a large sculpture by Francis Chantrey depicting David Pike Watts on his deathbed blessing his daughter Mary (Jesse's first wife) and her three children.

According to the report of the Archdeacon's visitation in 1843, the church was in a rather poor state at this time. But it was restored in 1855 by Gilbert Scott, who designed the ornate gothic interior that we see today.

The Font
Inside the church stands the magnificent Saxon font, which is worth a visit in itself. It is carved with six crude pictures in arched recesses, which include a half-figure of a man as well as a monster devouring a human head.

A walk through Congreve's grotto.

Above, left and right and opposite left: In spring the sight and smell of the wild garlic is overwhelming, complemented by bluebells and a profusion of other wild flowers.

Maiden's Garlands

Above the entrance to the chapel are two virgin crants or maiden's garlands, which signify the burial of a girl or unmarried woman in the parish. They were made by the woman's friends and family, as a tribute to her purity, of gloves, handkerchiefs and flowers made of paper.

The garlands were carried on the coffin of the woman and remained in the church if no one challenged the lady's virtue. Shakespeare's Hamlet speaks of maiden's garlands in Ophelia's funeral scene. These are rare survivors found in only a handful of Peak District churches, including Eyam, Matlock and Ashford.

Above right: The Battlestone is thought to commemorate a battle with the Danes.

Directions (cont.)

3. After leaving Ilam church continue down the hill towards the river. You will see a walled enclosure which houses St Bertram's well.

4. A little further on you will see an old bridge across the Manifold. This is St Bertram's Bridge, an access bridge for the old hall which leads to the South West Lodge of the estate. Don't cross the river, but turn upstream when you reach the bridge. Walk past a small weir – and, on your right, the site of the bandstand where bands would play to entertain the hall guests – to join the riverside path.

5. Shortly after joining the path, just above a second weir, you will see the 'boil holes', where the water from the River Manifold resurges; 8 miles upstream near Wetton it took an underground course. The river disappears completely in summer leaving a dry riverbed for the last few miles of its journey.

6. Follow the river (or often dry bed in summer) upstream. You are at the beginning of the aptly named Paradise Walk, created as a place where the hall guests could take their exercise. On your right, in the woods, lies a grotto where the playwright William Congreve is said to have written his first play, *The Old Bachelor*, in 1689.

7. Continue along the well-marked path. On your right you will see 'The Battlestone', a Saxon cross unearthed during the building of the new Ilam village.

8. At the end of Paradise Walk you reach the river again. Continue upstream until you reach a path coming in from the right. This crosses the park diagonally to bring you back to the hall, and the Old Stable Block which now houses the National Trust tea room, visitor centre and shop, close to your starting point, the car park.

Chapter 7

The Manifold Valley

The Manifold Valley today is a quiet and serene place. By the time she joins the Dove close to Ilam, the River Manifold has run for 12 miles, some of it underground during the spring and summer months. The Manifold has long been overshadowed by her 'sister' river, the Dove. But the lower limestone section in particular contains valleys just as beautiful as Dovedale, though darker and colder because of shading trees.

Today, along the banks of the gently trickling Manifold, families of cyclists pedal. Walkers amble along the woodland paths of her southern section and climbers take advantage of some spectacular limestone crags and caves that flank her banks. But in former days this was a much noisier place. Trains careered down the valley, taking farmers to market in Leek, milk to the creamery at Ecton and tourists to visit the spectacular Thor's Cave. Blasts of gunpowder shook the air from the twenty copper and lead mines that peppered the area. Packhorse trains, up to eighteen horses long, clattered over the bridges that crossed the river, taking copper from Ecton to Whiston and bringing back coal for the steam engines at the mines.

This chapter looks first at the course of the river as she winds her way to join the Dove near Ilam. A moderate walk and a cycle ride (along the bed of the old railway track) are recommended in order to fully appreciate the Manifold Valley and take in, as well as the beauty and serenity of the valley today, some of her history since the days when the Valley's hunter-gatherers would catch reindeer and collects nuts and berries to eat from their homes in the vast caves that look down over the river from the hillsides above.

The Course of the Manifold

The Manifold, just like the Dove, rises under the dark shadow of Axe Edge, to the south of Buxton. Its name is thought to come from the Anglo-Saxon *manig-fald* (many folds) reflecting its meandering nature. It keeps close to the Dove initially, meandering through gritstone moors in a deep valley until it passes just south of Longnor. Past Longnor, however, the two valleys diverge and assume very different characters. While the Dove continues to pass through spectacular hills, the Manifold Valley flattens, with distant views across fields surrounded by hedges rather than dry-stone walls.

It reaches limestone at Ecton near Hulme End, where it undergoes a sudden transformation. So far its surroundings have been unremarkable, but here the scenery

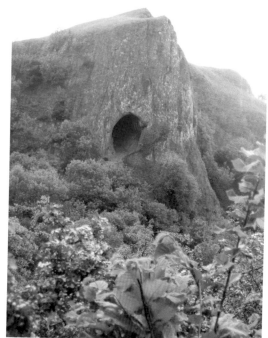

Above left: Fenced-off mine shafts provide evidence of Ecton Hill's copper-mining past.

Above right: Thor's Cave gapes darkly from an outcrop of grey limestone almost 300 feet above the riverbed. The cave has yielded many objects of archaeological interest, which show it was inhabited by both early man and prehistoric animals.

changes dramatically as it enters a deep limestone valley. The Manifold sweeps on past Ecton Hill, once the site of the most productive copper mine in England. Ecton Hill is still dotted with numerous fenced-off mine shafts which are currently being excavated.

It passes by Swainsley Hall, built by a Leek mill owner, and the 164-yard-long Swainsley road tunnel. The Manifold Valley becomes deeper and grander now, with crags such as Ossam's Crag, until it reaches the old watermill at Wetton Mill.

Just beyond the mill the river usually disappears underground during most summers, so from here to Ilam the Manifold is often dry between May and October. If you follow the course of the riverbed, Thor's Cave comes into view. This is a huge cave in a prominent spur high above the valley, which can be seen for miles around. About 2 km below Wetton Mill, close to the massive limestone crag Beeston Tor, the Manifold joins the Hamps Valley as her waters are supplemented by those of her major tributary, the River Hamps.

The cycle track and footpath (formerly the Leek & Manifold Light Railway) now leaves the River Manifold to follow the course of the River Hamps upstream in a south-westerly direction, to the southern end of the line at Waterhouses. The Manifold, however, flows south-east towards Ilam through a grand, often wooded valley.

Castern Wood here is a nature reserve and the woodlands lower down are designated Sites of Special Scientific Interest, on account of their lime trees. Just upstream of Ilam

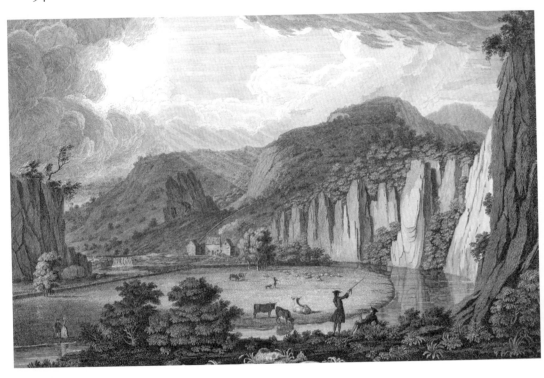

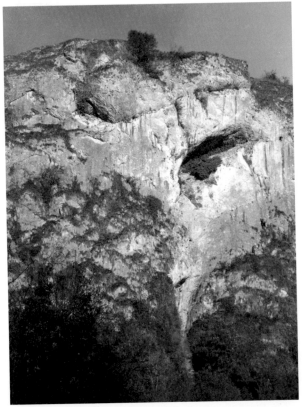

Above: 'A Prospect on the River Manyfold at Wetton Mill' by Thomas Smith, published 1743. The sixteenth-century mill house seen in this picture was used as a corn mill until 1857. (DMAG300201. Courtesy of Derby Museum and Art Gallery and www.picturethepast.org.uk)

Left: At the foot of this crag (Beeston Tor) lies St Bertram's cave, where the saint is said to have lived as a hermit. When it was excavated in 1926, Saxon brooches, coins and rings were found, so the cave was certainly used during this period.

The combined waters from the rivers of the Manifold, Hamps and Dove flow on past Thorpe Cloud towards the villages of the mid-Dove, east of Ashbourne.

Hall the water from the Manifold reappears at the boil holes and the river flows again whatever the season. Despite the fact that the Manifold is easily the more substantial river, the combined waters of the Manifold and the Dove, as they flow on beyond Ilam and Thorpe, are known as the River Dove.

Enjoying the Manifold

On Foot in the Manifold Valley

This circular walk begins and ends at the old water mill at Wetton Mill, where you can enjoy refreshments at the tea room. There is ample free parking at the side of the roads close by. Visitors to the tea room can drive over the bridge into the mill yard and park in the designated area.

This circular route is about 4 km, and takes about two and a half hours. It takes in the village of Wetton, some spectacular views across the Manifold hills and grasslands, and a visit to Thor's Cave before returning to Wetton Mill along the course of the river via the old railway track. It includes one fairly steep climb.

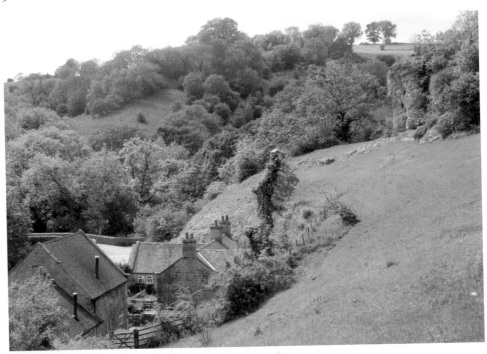

Some believe that the Rock Shelter on Nan Tor (behind Wetton Mill) was the Green Chapel of the Green Knight. Whatever its history, it is full of fascinating fossils and provides a wonderful viewpoint with some fine views of Thor's Cave across the valley.

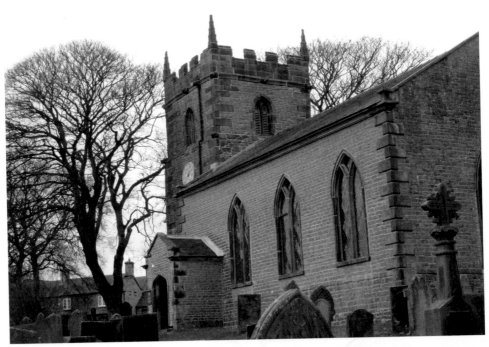

The parish church of St Margaret in Wetton was rebuilt in 1820, but the tower dates from the fourteenth century.

Directions

1. Having parked your car, walk past the picnic tables and take the signposted footpath that leads up behind the mill. Pass through a gate.

2. Turn left here if you would like to take the opportunity to explore the Wetton Mill Rock Shelter just behind the tea room. This cave is a Mesolithic site where bones of Arctic animals have been found. According to some scholars, this is a place of legendary power.

3. Retrace your steps back to the gate, then continue straight on (or right if you have come through the gate and opted not to visit the cave), up the hill.

4. At the top of the hill, follow the footpath sign that points you diagonally left across a field to a gate, and then continue along the footpath. At the bottom, turn left to take the footpath which goes around the hill.

5. Follow the path (which can be very muddy in winter) for about half a mile until you approach a farmhouse on your left. Take the path on your right before you reach the farmhouse up the grassy slope, keeping the wall on your left. Cross over the wall via the stone steps at the top of the hill, then immediately over a wooden stile on to the hill top.

6. Cross the hill following the clearly marked path. From here you will enjoy some fine views in all directions, including towards Thor's Cave. Squeeze through a waymarked hole in the wall to follow the path through the outskirts of a farmyard, and then walk down into the lane to the centre of the village of Wetton.

The Olde Royal Oak public house in Wetton was once famous for its annual toe wrestling competition!

Wetton

Wetton is a characterful, stone-built farming village, consisting mainly of farmhouses and cottages. In the summer it is a picture with its pretty cottages and lovely gardens, and popular with holidaymakers as it has an abundance of holiday accommodation. The very tidy village noticeboard even provides a map, showing precisely where the holiday accommodation is located. It has an inn and a partly fourteenth-century church which has an external staircase to its belfry.

Quite recently this innocuous-looking village became home to one of Derbyshire's more bizarre customs, the annual toe wrestling competition (although sadly, it doesn't take place here any more).

Toe Wrestling

The sport of toe wrestling originated at the Olde Royal Oak in Wetton in 1976. It was raised to a championship event in 1993 and attracted contenders from all over the world. The 'wrestle' consisted of raising one foot off the ground, while the toes of the other foot engaged the opponent's, and each contender tried to push the other's foot over a line.

Although it no longer takes place in Wetton, during the years it operated it raised a lot of money for charity and kept the pumps at the Olde Royal Oak busy.

7. At the junction at the bottom of the lane, turn right towards Wetton Mill and the Manifold Valley. A few yards out of the village (ignoring the turning on the left) a farm track branches off left and is signed as a concessionary footpath to Thor's Cave.
8. Follow this path down a small dale with spectacular views across the lush grasslands of the Manifold Valley.
9. When you reach the 'No Access' sign, take the stone steps over the wall on your right. Then bear left down the hill, keeping the stone wall on your left. Looming before you is the massive limestone crag in which Thor's Cave lies.
10. Pass through a wooden gate. If you have a very good head for heights (and do not have children or dogs with you) you may wish to turn left and proceed to the top of the crag for a particularly fine view of the Manifold (or her dry bed in the summer months) and along her lush valley. But beware! The drop from the top is sheer and unprotected. Otherwise turn right down the path, which will very soon bring you to Thor's Cave. This has been described as the most spectacular sight of the Manifold Valley. The cave entrance forms a 10-metre hole in the giant rock in which it is set, and is clearly visible for several miles. The origin of the name is uncertain. Some people think that it comes from Thor, the Norse god of thunder, but it is more likely to be a corruption of 'tors', meaning hills. Excavations have shown that the cave was occupied as long as 10,000 years ago and this occupation probably continued until Roman or Saxon times, making it one of the oldest sites of human activity in the Peak. Stone tools and the remains of a range of now-extinct animals were found within the cave.
11. From the cave return the way you came to the fork in the path.
12. Turn left down the wooded hill to the river and cross over the footbridge.
13. Turn right onto the old railway track (formerly the Leek & Manifold Light Railway) and enjoy a leisurely walk back to Wetton Mill.

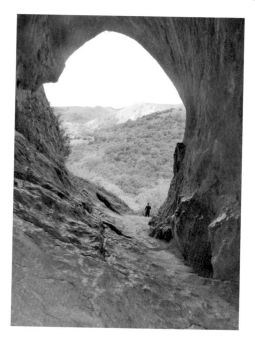 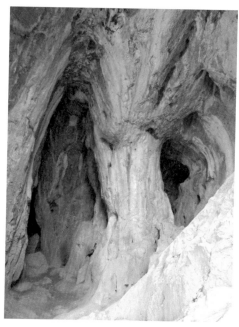

Above, left and right: A slippery scramble into Thor's cave is rewarding, with some astonishing shapes and colours.

Thor's Cave has been used by rock climbers since the 1950s. At least eleven limestone routes are listed by the British Mountaineering Council (BMC) at the site of the cave ranging in grade from Very Severe to E7. A few routes are bolted.

Steps through woodland take you down from Thor's Cave to the River Manifold.

On Two Wheels along the Manifold Way

The Manifold Way is an 8-mile (13-km) walk and cycle path which follows the line of the former Leek & Manifold Light Railway along the Manifold and Hamps valleys. Beginning at Hulme End at its northern end and terminating at the railhead at Waterhouses, it is a reasonably flat and easy cycle with a tarmacked path throughout. A short section is shared with a minor road. There are beautiful riverside, woodland and hillscape views to be enjoyed throughout. There is parking at the old railway station at Hulme End, although, as yet, no cycle hire. You can hire bikes, however, from the southern end at Waterhouses. The return trip takes three to four hours.

The Leek & Manifold Valley Light Railway

It is difficult to believe today that a railway line would have been constructed to run through this narrow, isolated and beautiful little gorge. But in 1904 the narrow-gauge line (2 feet 6 inches) was laid. It was built mainly to transport minerals from the Ecton Copper Mine and farm produce from the upland district west of Hartington. (In the early twentieth century up to 600,000 gallons of milk a year were transported from

Ecton Creamery to London.) It also carried coal, animal feedstuffs, mine spoil and beer from Burton upon Trent as well as providing a passenger service to residents of nearby villages and access to local beauty spots for the many visiting tourists.

The track followed the Manifold and Hamps valleys on their southward journey to Waterhouses – a distance of exactly 8.25 miles (13.2 km). Here it met up with the standard-gauge branch line from Leek, which formed part of the North Staffordshire railway system.

The trains consisted of two small steam locomotives built to an Indian design, fitted with large headlamps and pulling a rake of primrose-painted carriages with tiny verandas. They ran at a maximum of 15 mph through spectacular scenery, the track crossing the Manifold several times during its short journey. There were ten stations or stops but most halts were run on a request basis with trains even stopping to pick up passengers on the lineside footpath. There were refreshment rooms at Thor's Cave and Beeston Tor.

One of the labourers working on the construction of the line commented at the time, 'It's a grand bit of line, but they wunna mak a go of it, for it starts from nowhere and finishes up at the same place!' His words proved prophetic. When the mine workings at Ecton closed due to non-profitability, and produce from the farms began to be transported by road, its fate was sealed. It finally closed in 1934 after thirty years of struggling. The track was removed in 1937 at which point it was given to Staffordshire County Council, who spent £6,000 repairing fences and parapets and resurfacing in order to create the National Pedestrian Path now known as the Manifold Way.

Following the Manifold Way

Directions
1. The cycle trail begins at Hulme End, which was the headquarters of the Leek & Manifold Valley Light Railway. There was a range of railway buildings at Hulme End, including engine and coal sheds, many of which remain to this day.
2. The route leaves the car park on a well-surfaced track, wide enough for two people (or cyclists) to pass side by side. After a short distance you will see Ecton Hill looming on your left. Look out for the raised loading platform that once served Ecton Creamery. Looking up the hillside through the trees to the top of Ecton village you will see an impressive copper roof. This belonged to the manager's house of the former Ecton Copper Mine.

Ecton Hill and Copper Mine
Ecton Hill has been mined for copper since the sixteenth century. It was leased by the owner, the Duke of Devonshire, until in 1760 the then Duke decided to work it on his own account. In its heyday, in the second half of the eighteenth century, the Ecton Copper Mine was the deepest and one of the most productive copper mines in the country, producing over a 1,000 tons of ore a year. It was unique in being a rich copper mine in an area of Derbyshire usually associated with lead mining.

To start off with, the ore was carried by packhorse to Denby for smelting, but in 1769 the Duke opened his own smelting works at nearby Whiston in the Churnet

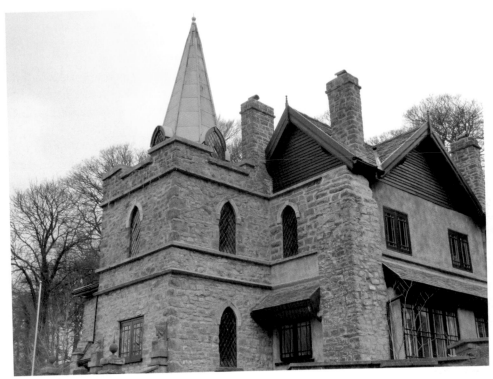

At the top of Ecton you may be able to discern the old manager's house for Ecton Copper Mine, once the most productive copper mine in England.

In the eighteenth century the Duke of Devonshire extracted enough copper from Ecton Hill to pay for the development of the Crescent at Buxton (above) with merely a year's profit, as well as financing ongoing additions to Chatsworth House.

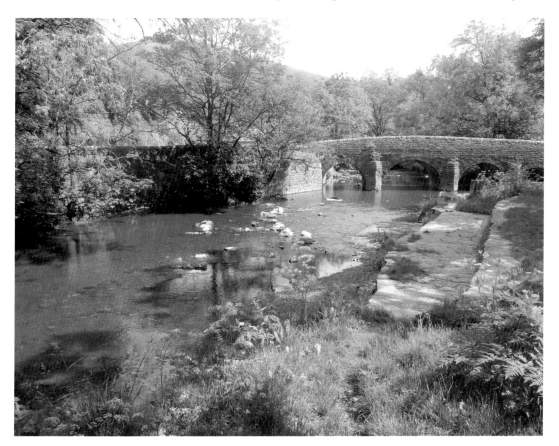

This handsome bridge at Wetton Mill was built by the Duke of Devonshire in 1807. Trains of up to eighteen packhorses carried the copper ore across the bridge from his Ecton mine for smelting in Whiston.

Valley. Much of the copper was used for making brass, but over 300 tons were supplied to the Navy to protect the hulls of its ships against boring worms.

By 1790 the mine was employing 400 workers – men, women and children. But by 1800 the ore had almost been worked out and the Duke relinquished his interest (having made almost a third of a million pounds in profit).

3. Shortly beyond Ecton you reach the road section of the trail at the entrance to Swainsley Tunnel. It is said that this tunnel was built at the insistence of Sir Thomas Wardle, a Leek & Manifold Light Railway director, so that the view from the neighbouring Swainsley Hall should not be spoiled by the railway and to keep the noise and fumes of the trains away from the hall.

4. Cycling down the road from Swainsley Tunnel will bring you to Wetton Mill. You will rejoin the tarmacked track a short distance beyond.

5. Carrying on southwards you will soon see Thor's Cave gaping out of its huge crag on your right. If you haven't already explored it, it is well worth leaving your bike here and crossing the bridge which leads to a steep but short woodland climb

You will pass over the Hamps several times as you cycle up the Hamps Valley.

up to the cave. Sadly there is very little evidence left of the railway station that delivered hundreds of visitors to make the climb.

6. A short distance further on, the track crosses the road at Weag's Bridge. Take the signposted cycle track on the opposite side of the road.

7. You will soon see Beeston Tor on your left, probably with climbers clinging precariously to her great limestone walls. From here you will bend round to the west to follow the course of the River Hamps, leaving the Manifold to wind its way on towards Ilam.

8. Continue on the tarmacked path along the Hamps Valley, which today is pleasant, rural and wooded in places. But when the railway was built, the valley was devoid of trees and to any tourists travelling the line to visit Beeston Tor or Thor's Cave it would have seemed a rather wild place. This part of the route has a steady uphill gradient, and you may well be grateful for the farm offering teas a couple of kilometres before you reach Waterhouses.

9. A final short climb brings you to the Waterhouses terminus.

Chapter 8

Mappleton, the Mayfields and Ashbourne

Supplemented now by the waters from both the Hamps and the Manifold, the Dove becomes a far more substantial river. It is not only the river that begins to look different, as you follow her southward course. The countryside becomes flatter and more suburban, and the building style of the villages along her banks undergoes a noticeable change. Mappleton, unlike her limestone-built northern neighbour Thorpe, is built almost entirely of red brick. We have now moved over the boundary of the limestone which surrounds Dovedale and the White Peak, on to the red sandstone of southern Derbyshire.

Just over the Dove from Mappleton lies the Okeover estate. Mappleton and Okeover, like many of the villages of the surrounding countryside, were owned by representatives of the local gentry. Like Ilam under the Watts-Russells and neighbouring Tissington under the Fitzherberts, it was a 'closed' community dominated by its landlord with a prominent hall and park.

Robert Plumer Ward (author of *The Law of the Nations, Tremaine, De Vere*, etc.) married into the Okeover family in the early nineteenth century and was delighted by the place:

> I feel more comfortably off in this delightful, as well as respectable old abode, than ever I was in my life … There is really a corner of England left, in which the old-fashioned feeling of attachment from well-used tenants to an old landlord's family, is still preserved. I never saw it so exemplified as among all the tenants of this beautiful estate upon our arrival …[9]

Nearly 200 years later there is still a feeling of respectable, old rural England about this region, formerly dominated by its ruling gentry. Their often elaborate tombs and remembrance plaques still preside in the ancient village churches on both Derbyshire and Staffordshire banks of the Dove.

It is an area rich in history. Prince Charles Edward Stuart (otherwise known as Bonnie Prince Charlie or the Young Pretender) marched his army proudly through this part of Derbyshire on his way southwards, where he intended to claim the throne. He returned defeated and his troops wreaked havoc, leaving visual evidence of these more violent days.

A more substantial Dove flows on towards Mappleton.

Many of the buildings in Mappleton are built of red brick.

Beginning with a strange and chilly custom in Mappleton, this chapter moves on to look at the Mayfields, a village which, pockmarked by history and dissected today by major roadways, still retains its rural charm. The market town of Ashbourne (bypassed by the Dove but linked by the River Henmore and the sound of St Oswald's famous church bells) was traditionally the fashionable place to stay for eighteenth-century visitors to Dovedale. Steeped in history, combining a medieval street pattern with historic buildings, a cobbled market place and hidden alleys and yards, it has changed little in appearance since that time. It is impossible to resist a 2-km sidetrack to visit this fascinating and beautiful town.

Mappleton and Okeover

The pleasant village hamlet of Mappleton sits on the Derbyshire side of the River Dove, while neighbouring Okeover, with its grand hall and gardens lies in Staffordshire, just over Mappleton's one-arch bridge, famous for its chilly New Year tradition.

The Dove's Most Famous Jump

The New Year's Day Mappleton bridge jump has become legendary. Annually, at noon on New Year's Day, ten teams with three paddlers each paddle rafts half a mile down the river to the bridge. Once they arrive they scramble up the bank, run to the top of the bridge, then leap from the parapet, 30 feet down into the freezing water below!

Those that survive then run 500 yards down the road to the white-painted Okeover Arms in Mappleton. The winner receives ten free pints of ale. Not surprisingly, far more people come to watch the spectacle and enjoy subsequent refreshment at the pub than to actually partake!

But there is more to Mappleton than this strange and ancient custom. Though perhaps not as picturesque as Ilam and Thorpe, it has its history and charms. The village has existed, in some form or another, since before 1086, when it gets a mention in the Domesday Book. One exception to the brick and whitewash is the eighteenth-century village church of St Mary's. This tiny domed structure with a pillared porch was designed and built by James Gibbs, a former pupil of Sir Christopher Wren, designer of St Paul's Cathedral in London.

The Okeover Estate

The Okeover family have owned the estate just over the bridge from Mappleton for many centuries, and Okeover Hall, which is surrounded by an extensive deer park, was built around 1720. It is a private estate with a grand hall, gardens and its own church, none of which are open to the public, but a quiet road to Mayfield and some interesting public footpaths cut through it.

Above and left: Today a beautiful and tranquil place, St John the Baptist's church in Mayfield was once the site of violence and terror. Bullet holes remain in the west door where Bonnie Prince Charlie's troops fired at terrified villagers seeking refuge in the church.

The Mayfields

A quiet back road just over Mappleton Bridge follows the course of the Dove through the Okeover Estate to Mayfield. Mayfield is a scattered village, made up of three main areas, Church Mayfield, Upper Mayfield and Middle Mayfield, though each area could be classified as a village in itself. The entire village lies in Staffordshire. Its tranquility is somewhat shattered by the A52 trunk road which runs along its eastern boundary, and by the busy B5032 to Uttoxeter which runs through the centre.

The village pre-dates the Domesday Book (where it gets a mention as Mareveldt) but its niche in history lies in 1745. For it was here, on 7 December, that the army of Bonnie Prince Charlie terrorised the local population.

The Young Pretender

In 1714 the English throne was inherited by a German prince from Hanover, George I. Many people, however, supported a rival claimant, James Stuart, the son of King James II. They were known as Jacobites. In 1785 James's exiled son Charles Edward Stuart (Bonnie Prince Charlie) launched an invasion of England with a largely Scottish army of about 10,000 men together with horses, wagons and cannon. They marched through Ashbourne on their way to Derby, plundering goods from shops, and food

Christopher Wren's influence can clearly be seen on the design of the tiny eighteenth-century church of St Mary's in Mappleton.

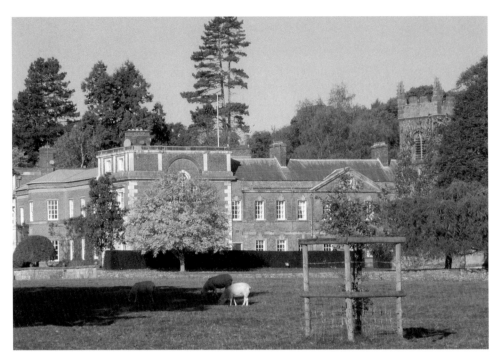

'This is a fine specimen of the mansion of an old English squire, surrounded by venerable trees, adorned with extensive and ancient gardens and shrubberies and enjoying all the advantages which the immediate neighbourhood, the most picturesque scenery of Derbyshire, can bestow.' (Sir Bernard Burke on the Okeover Estate).[8]

and livestock from local farms. The prince triumphantly proclaimed his father king in the market place there on 3 December 1745, before continuing his march to Derby.

He arrived in Derby on 4 December, but it was here that he was persuaded that due to the rumoured amassing of English troops he had insufficient men to carry out the task. He reluctantly decided to retreat. His troops returned, staying in Ashbourne overnight, commandeering Ashbourne Hall for their quarters. They headed on to Mayfield, where the wild behaviour of the hungry Highlanders caused panic that was to echo throughout the Peak. They shot a local innkeeper as well as a certain Mr Humphrey Brown who refused to hand over his horse to them. Many of the villagers took refuge in the church, locking themselves in, behind the west door – upon which the Scottish soldiers vented their frustration, leaving the bullet holes in the woodwork that can still be seen to this day.

In those days there was an old packhorse bridge over the River Dove. The 500-year-old grey arches of this original bridge can still be seen beneath the larger modern construction. Legend has it that many of the Scottish rebels were caught and tried for their misdeeds. They were hanged from gibbets erected on the old stone bridge.

St John the Baptist's Church

The scene of this violence, St John the Baptist's church in Mayfield, is thought to have been originally built around 1125 during the reign of Henry I. But it has been added

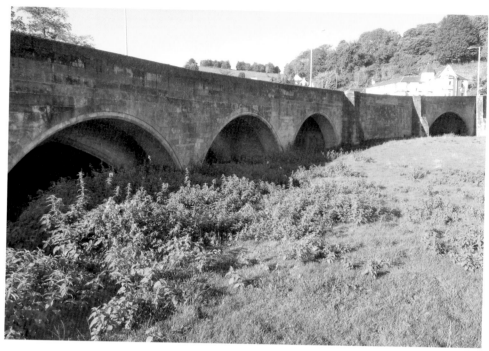

A gruesome past disguised? The original structure of Mayfield's old packhorse bridge can be seen under the widened road bridge which was built in 1937 to carry the busy A52 over the River Dove. It is here that Scottish rebels were hanged from gibbets erected on the old bridge.

to and rebuilt substantially over the centuries. The fabric and nave arcade are twelfth-century, the chancel fourteenth-century and the tower sixteenth-century.

Mayfield Mills

There has been some sort of mill in Mayfield since the thirteenth century. A property valuation in 1291, when most of Mayfield belonged to the priory of Tutbury (see Chapter 10), included a corn mill. By 1793 the site had developed to include two corn mills, two fulling mills and a leather mill. Textiles first appeared in 1795 when the cotton mill was completed. It was destroyed by fire in 1806, together with most of the machinery, but was rebuilt with a cast-iron framework and brick vaulted ceilings (which can still be seen in the oldest buildings today) to avoid a repetition of the disaster.

Cotton spinning continued in Mayfield until 1934, when the mill was sold to William Tatton and company, who used it to process silk.

A Famous Mayfield Resident

It was the sounds coming from a church some 2 miles away on the other side of the river in Ashbourne, that inspired the great ballad writer Thomas Moore (1779–1852), who lived in Mayfield for a time, to write one of his best known ballads, 'Those Evening Bells'. From his cottage formerly known as Stancliffe Farm (which now bears his name instead), he also composed other works that have since become well known, including 'Lalla Rookh'.

The graceful spire of Ashbourne's St Oswald's church is a noted landmark rising to 212 feet.

Moore was a great friend of the poet Lord Byron, who visited him at his country cottage in Mayfield. Moore blessed his daughter with the name of his great friend. Her name can still be seen on her slate tombstone in the churchyard, where she was buried when she died tragically at a young age.

Ashbourne

The large and ancient St Oswald's church, whose bells inspired Thomas Moore, dominates the market town of Ashbourne. Ashbourne is still known today as the 'Southern Gateway to the Peak District'. The church seems disproportionately large for a small rural town, being 176 feet longer than most rural churches.

The present building was mainly built in the early 1200s. It has the oldest dated brass plaque in the country, recording its consecration on 8 May 1241. But it is known that an Anglo-Saxon church served by a priest existed on the current site at the time of the Domesday Book (1086 AD) in which Ashbourne is listed as a well-established town under its medieval name of Esseburn – from 'aesc' (the ash trees) plus 'burna' (a stream or brook).

The church has had many distinguished visitors. King Charles I attended a service here and signed the register, but unfortunately this was stolen during the last century. Dr John Taylor, who lived at 'The Mansion', one of the fine old Georgian properties on Church Street, worshipped here too with his friend Dr Samuel Johnson. Dr

The white figure of Penelope Boothby is so lifelike that she appears to be sleeping.

Johnson, who published his famous dictionary in 1755, often visited Taylor at his home.

Church Interior

The church contains a particularly fine collection of medieval tombs of the powerful local gentry families of Cockayne, Boothby and Bradbourne. The best known, and possibly the church's greatest treasure, is a carving by Thomas Banks of Penelope Boothby, who died in 1791 aged just five years old.

Penelope Boothby

Penelope was the only child of Sir Brooke Boothby, the owner of Ashbourne Hall. Her father worshipped her. She was painted by Sir Joshua Reynolds when she was three. Tragically, Penelope died just before her sixth birthday in 1791 and broke her father's heart. After her death she was immortalised by Thomas Banks in a white marble carving inside St Oswald's church.

Penelope's epitaph reads, 'She was in form and intellect exquisite, the unfortunate parents ventured their all on this frail bark, and the wreck was total.' Her parents separated at her burial and her father spent the rest of his life travelling on the Continent. Penelope subsequently became something of a celebrity. Little girls across the country used to go to fancy dress parties dressed as Penelope. Banks's carving was exhibited at the Royal Academy and visited by Queen Charlotte, who, on hearing the sad story, is said to have wept.

Left: 'The Mansion', where Dr John Taylor lived.

Below: Originally granted a charter for a market in 1257, the Market Place in Ashbourne still 'buzzes' every Thursday and Saturday.

The Owfield's almshouses were built originally as single-story dwellings in 1610–48. The upper floor was added in 1848.

Church Street

Leading from St Oswald's into the town is Church Street, known as one of Derbyshire's finest Georgian streets. The Georgian period was undoubtedly Ashbourne's heyday. Between 1700 and 1820 the town's medieval timber-framed buildings were replaced by brick and stone as it became a busy and fashionable centre for the wealthy. Six coaching roads met here, including the route from London to Carlisle, and the street boasts many fine Georgian houses.

These fashionable houses were built by well-off tradesmen, clergymen, doctors and lawyers who organised their own 'social season' with dances, card parties and theatrical performances. The town became a resort for fashionable tourists, mainly coming to visit Dovedale, attracting literary figures such as Dr Johnson. Coaching inns like the Green Man, served travellers on the main London to Manchester turnpike road.

The Green Man has been the main inn and social point of the town for centuries. Many famous visitors are reputed to have stayed here, including Princess (later Queen) Victoria, in the early 1830s, who stopped off for a comfort break; James Boswell (Johnson's biographer); and one Mademoiselle de Jeck, an elephant who apparently wandered down Church Street like a dog, behind her master's horse. Townspeople paid a penny to visit her.

Today the gallows-style inn sign for the Green Man and Black's Head Hotel on the opposite side of the street (the two inns were amalgamated in 1825) greets visitors to the town as they proceed into St John Street.

In 1780 eight out of ten buildings on the south side of St John's Street were public houses. There were forty altogether in the town. A lot of their custom was generated by the regular livestock markets, horse fairs and cheese fairs that took place in the town, attracting local country people from miles around. Several groups of almshouses also

The Queen Elizabeth Grammar School.

Above left: The Tudor basement windows of Vine House.

Above right: The Lamplight Restaurant (formerly the Tiger Inn) is a Tudor building which has a projecting gable to the street.

The original wattle and daub of the fifteenth-century Gingerbread Shop was covered for many years by a mock Elizabethan front.

occupy Church Street. The Clergy Widows Almshouses were originally built for the widows of clergymen in 1753.

Older Buildings

Not all the town's fine buildings on Church Street are Georgian. One much older property is The Queen Elizabeth Grammar School, which stands opposite Taylor's Mansion. The school was founded in 1585 following a petition from five local gentlemen headed by the lord of the manor, Sir Thomas Cockayne. The petition claimed that due to their lack of an education the inhabitants of Ashbourne were 'given over to wickedness and vices such as swearing, drunkenness, whoredom, idleness and such like'.

Dr Johnson applied for the job of Under Master here in 1734, but his application was not successful. The building has now been converted to private apartments, being replaced by a new school built in 1909. Other properties also betray an older origin, most notably Vine House.

Vine House was built early in the eighteenth century on the base of a much older property. The Gingerbread Shop, a timber-framed building in St John's Street, dates from the fifteenth century.

Victorian Ashbourne

The town declined economically during the Victorian era as, with the advent of the railways, Ashbourne's coaching traffic collapsed. Although the railway came to Ashbourne it was only at the end of a branch line, so despite the summer tourists who still came to see Dovedale the town did not develop and became virtually 'fossilised' as the Georgian town which survives today.

The Town Hall was built as a market hall in 1861. Here monarchs are proclaimed. Bonnie Prince Charlie proclaimed his father king from an earlier building which stood here in 1745.

Its market continued to serve farmers and local needs. More recently developments for both industry and housing have been away from the old town, helping preserve the centre's Georgian facade.

The Shrovetide Football Game

There is much more to Ashbourne and many more fine buildings than can be described in one short chapter. But no 'flavour' of the town would be complete without reference to Ashbourne's most famous and eccentric tradition. Once a year everything comes to a halt in the town – shops close, windows are boarded for protection and everybody downs tools in preparation for the annual Shrovetide football game.

Medieval street football involving matches between neighbouring parishes was once commonly played throughout the country on religious 'holy-days' such as Shrovetide – the last day before Lent. The tradition was first recorded in Ashbourne in 1682 but is thought to date back to the twelfth century. It has been preserved in Ashbourne in its authentic form. It is played on Shrove Tuesday and the succeeding Ash Wednesday between two informal teams, much of the action taking place in the bed of the River Henmore!

The teams are known as the 'Up'ards' (anyone born to the north of the Henmore) and the 'Down'ards' (anyone born to the south of the river) – and anybody can play. The 'goals' are on the site of former corn mills on the Henmore, one at Sturston and one at Clifton, 3 miles apart on either side of the town centre.

The aim of the game is to strike a post with the ball which may be kicked, carried or thrown. The game is fiercely competitive. The ball spends most of its time being pushed through the streets in a 'hug' or scrum of twenty or more players.

Many attempts have been made over the years to ban the game, but by the 1920s it had become part of local life. It now enjoys international status and has received royal recognition. The ball was 'turned up' by Prince Edward in 1928 and by Prince Charles in 2003.

The Lower Dove

- Ilam
- Thorpe
- Mappleton
- **Ashbourne**
- Upper Mayfield
- Mayfield
- Middle Mayfield
- Calwich
- Church Mayfield
- Ellastone
- Snelston
- Norbury
- Doveleys
- River Churnet
- Rocester
- River Dove
- A515
- Marston Montgomery
- A52
- Doveridge
- **Uttoxeter**
- A50
- A518
- Sudbury
- River Dove
- Scropton
- Marston on Dove
- A50
- Tutbury Castle
- Tutbury
- Eggington
- Rolleston
- A515
- A511
- Stretton
- A38
- Newton Solney
- River Trent
- **Burton upon Trent**

Chapter 9

Beyond the Peak

The Dove flows on away from the Peak District through gently rolling countryside, less spectacular perhaps, but equally charming in its own way. Sleepy, winding B-roads follow her course on the Staffordshire side, beginning with the B5032 from Middle Mayfield, which heads out towards Calwich and Ellastone.

This chapter follows the Dove, initially through these quiet agricultural settlements. These are characterful villages with literary connections and ancient churches, with enjoyable strolls to be had along the river bank, often revealing some interesting relics and a few surprises. A short diversion takes us over Ellastone Bridge to Norbury on the Derbyshire bank of the Dove, with its medieval Tudor hall and manor house.

Continuing along the Staffordshire bank, we follow the river as she winds onwards towards the lowlands of southern Derbyshire. It is only when we arrive at Rocester that we are suddenly and abruptly brought back to the present day when we come face to face with the massive JCB World Headquarters.

The gently rolling countryside that flanks the Dove as she approaches Ellastone.

Calwich Abbey

The B5032 from Middle Mayfield initially follows the course of the Dove as she passes first through the village of Calwich. The village gives its name to the twelfth-century abbey, the site of which is said to have been visited by the composer Handel. The location is even said to have inspired some of his most important pieces including *Messiah* and *Water Music*.

The abbey, once the smallest Augustinian house in the county, was dissolved in 1536 and a Georgian-style country house was built on the site (around 1849–50). The building was largely demolished in 1935, but was Grade II listed in 1985. The listed building text describes a 'small country house' in a 'derelict and dangerous condition'.

Ellastone

A couple of kilometres downstream lies the village of Ellastone. Like many of the villages along the Dove, Ellastone dates back to Anglo-Saxon times and is listed in the Domesday Book (as Edelachestone, Elachestone and Princestone). The village will be of particular interest to readers of George Eliot's novels, for as proudly proclaimed on the village noticeboard next to the village hall, Ellastone is at the heart of 'Adam Bede country'.

Adam Bede Country
Born locally, George Eliot's father lived in Ellastone during the early part of his life, working as a carpenter. There is an Adam Bede cottage in the village reputed to be

The ruins of Calwich Abbey are now in a derelict and dangerous state.

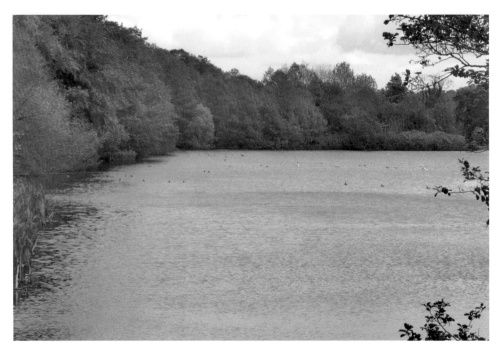

The lake at Calwich Abbey is said to have inspired Handel's *Water Music*.

linked to the family, although the link is debatable. But Eliot did use the village as the setting for some of the scenes in her novel *Adam Bede* (published in 1859). Hayslope, in Eliot's fictional county of Loamshire, was based on Ellastone and the Methodist references in the book fit the locality very well. The hamlet of Ramshorn at the western end of the parish of Ellastone was very significant in early Primitive Methodist histories. The village of Norbury, just across the river, also has connections with George Eliot's family.

A Circular Stroll from Ellastone through the Calwich Abbey Estate

This short circular walk (about one hour's easy walking) begins close to the bridge over the river Dove on the outskirts of Ellastone. It leads through the Calwich Abbey Estate and passes by the ruins of the old Augustian Abbey. You will enjoy some fine views over the surrounding countryside as you loop back into the village, through the churchyard.

Directions
 1. Park in Dove Street, a left turn off the B5032 as you head out of the village. Just past the old post office you will see a lodge house. Turn left onto a track.
 2. You may pass alpacas, donkeys and a variety of other farm animals as you proceed along this pleasant, long, winding path.
 3. After about a kilometre the ruins of the old abbey begin to come into view. Sadly, little evidence of the abbey remains, or the hall built in its place. Continue along

the path through the gate until you are almost opposite the ruins. The grounds of the abbey, which stretch down to the lake below, are noted for their spectacular display of snowdrops in the early part of the year. There is a pavilion close to the water's edge where it is said that Handel composed his *Water Music*.

4. Go through a gate on your left which leads into woodland. Follow the waymarked path (which leads back in the direction you have come from) until you reach a kissing gate.

5. Go through the gate into a field. Cross the field passing just below an island of trees, aiming towards a gate with a stile next to it on the far side of the field.

6. Cross over the stile, and then go across the next field and cross another stile to reach the road.

7. Cross over the road carefully (it can be busy) then follow the signposted path that points half left down the field in the direction of farm buildings. Cross another stile at the bottom of the field.

8. Continue down the rutted track to reach the narrow footbridge over the stream, just past the ford.

9. Cross over the bridge, then walk up the fields following the yellow arrows towards the road. Cross over the driveway and follow the short path to reach the stone stile giving access to the road.

10. Turn left past Northwood Farm and cottages. Cross a stile on the right into a field. Head across the field in the direction of Ellastone churchyard, crossing a number of waymarked stiles as you go.

The woodlands around Calwich Abbey are spectacular in February.

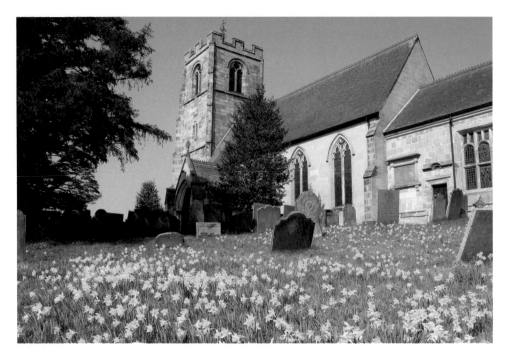

The sixteenth-century church of St Peter's dominates the village of Ellastone.

11. Pass through the kissing gate into the churchyard. The local church of St Peter's dates back to the sixteenth century and displays the year 1586 prominently on its tower. George Eliot's grandfather is buried here, in the churchyard.
12. Turn left and follow the path through the churchyard, then through the lynchgate, then turn left down Church Lane. Turn left at the junction, then right a little further to return to Dove Street on your left.

Lower Ellastone

If you continue down Dove Street you will come once again to the banks of the Dove where Ellastone Bridge takes you back into Derbyshire. During the Second World War this bridge was an important crossing point. You can still see the two pillboxes, one on each bank, which guarded the crossing. There is a beautiful short walk along the Dove from the bridge at Ellastone to the church at Norbury, which sits on the river bank less than a couple of kilometres away.

Norbury

Norbury is listed in the Domesday Book as Norberre or Nordberie – in other words the 'norther' defence on the Dove, as opposed to Sudbury further down the river to the south. Norbury Mill is also mentioned, and flour was ground here up until 1890. Norbury is also famous for its George Eliot connection. Eliot's father sang in the Norbury church choir and several members of the family are buried in Norbury churchyard.

Bridge over the River Dove at Ellastone.

The church itself, dedicated to St Mary and St Barlok, is a magnificent building inside and out. The lofty chancel, with its four large windows containing fourteenth- and fifteenth-century glass, has been described as a 'lantern in stone'. Within the chancel lie the tombs of the Fitzherbert family, who, as well as building various parts of the church, built the manor house and Tudor hall next door.

Norbury Manor and Hall

Norbury Manor, on the Derbyshire bank of the Dove, is an original medieval manor house on to which a Tudor hall has been built at a right angle. The manor house was built of stone in the mid-thirteenth century for William Fitzherbert and enlarged around 1300 by Sir Henry Fitzherbert. It still has many original features, including the undercroft with the hall above on the upper floor, a rare king post, a medieval fireplace, a Tudor door and some seventeenth-century Flemish glass.

The house was enlarged by Ralph Fitzherbert, who added the Tudor hall at the end of the fifteenth century. In the mid-sixteenth century, however, it fell into disuse as Sir Thomas Fitzherbert married Anne Eyre, heiress of Padley Manor, and the family moved to Padley on her father's death.

During the English Civil War, the hall was badly damaged by the Parliamentary forces. Sir John Fitzherbert was a staunch supporter of the Royalist cause and was killed at Lichfield in 1649. William Fitzherbert inherited Norbury in a ruinous state. He rebuilt the Tudor portion of the property in brick around 1680, but retained much of the Tudor panelling and stained glass. The Fitzherberts sold the estate in 1881 and since 1987 this Grade I listed building has been owned by the National Trust. It is open to the public in the summer months, but only by written appointment with the tenant.

The church at Norbury stands next to Norbury Manor and Hall.

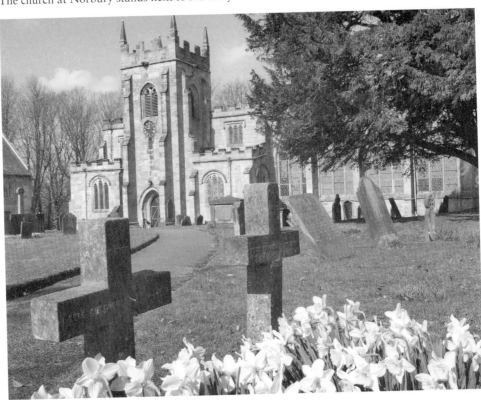

Salmon on the Dove

Immediately behind the picturesque Norbury church, manor house and hall, the Dove flows over a weir, popular with local fishermen as a haunt for trout and grayling. But in recent years they have been in for a surprise. For the Environment Agency and the Trent Rivers Trust recently introduced 120,000 salmon into the River Dove at Eaton, Dovedale, as part of an ongoing project to re-establish a sustainable population of Atlantic salmon. Fishermen have been surprised and delighted to see these, leaping up this and other weirs along the Dove, as the fish return to their spawning grounds.

To increase their chances of survival the salmon are reared at the Environment Agency's Kielder Hatchery, where the fry hatch out. When they reach around 5 to 7 cm in length they become known as parr and are ready to be released into the river. They stay there for up to two winters, feeding and growing, before beginning the 130-mile journey down the Dove, joining the Trent at Newton Solney and then on to Hull, before heading for the Atlantic and beginning their remarkable journey across the ocean. Those that survive return to the Dove after spending the winter at sea. Norbury and other weirs will eventually have a 'fish pass' to make their return journey to the spawning grounds easier. A pass has already been successfully installed at Tutbury Weir, further down the Dove, where the salmon can also be seen, leaping from the waters in autumn.

Martin Stark, Chairman of the Trent Rivers Trust, had this to say about their release:

> Salmon are icons. They experience this epic journey from freshwater to sea and back again. It was the activities of man which led to their decline but now river conditions have improved so much, we are delighted to be helping to restore a run of fish back to this famous river.[10]

Doveleys

Continuing along the Stafforshire bank, the river flows on through the beautiful countryside of Doveleys Manor Park. A garden centre has been built alongside the manor house, which dates back to 1831.

The Industrial Impact

It is something of a shock when, from this serene parkland and agricultural countryside that have graced the banks of the Dove so far, a short distance downstream we are suddenly confronted with the impact of the Industrial Age. In 1781 Arkwright purchased an old corn mill on the River Dove on the outskirts of Rocester and turned it into a water-powered cotton mill, transforming the town's economy within a few years from mainly agricultural to semi-industrial.

At one time Tutbury Mill, at four storeys high and twenty-four bays long, was the main employer of the region. Today JCB (founded in 1945 by Joseph Cyril Bamford in a small garage in nearby Uttoxeter) have taken over that role with their famous yellow diggers and tractors. They have several offices and factories in Staffordshire, as well

Fishermen have been amazed to see salmon leaping up this weir in recent autumns.

The manor house overlooking the Dove at Doveleys Manor Park is currently unoccupied and due for restoration.

The ornamental lakes and extensive water features of JCB's headquarters in Rocester now attract many species of wildlife and waterfowl.

as their Rocester headquarters which have been carefully landscaped to blend in with the countryside. Fittingly, both Arkwright's cotton mill and the corn mill on the River Churnet at the opposite side of the town have been put to good use by the company.

Rocester's Augustian Abbey

Right next to the JCB academy, and in stark chronological contrast, lie the peaceful Abbey Fields, a scheduled Ancient Monument where sheep now graze silently and contentedly. The abbey of St Mary at Rocester in Dovedale was founded some time between 1141 and 1146 by Richard Bacon, a nephew of Ranulph, Earl of Chester. The order was disbanded in 1538 and later a manor house, Rocester Hall, was built on the site but this had been demolished by 1660. Undulations in the field betray evidence of the abbey's presence and a man-made hollow is thought to have been its carp pool.

The abbey never became wealthy. Its comparative poverty is shown by its assessment at 10s, for the aid of 1235/36 – the same as the much smaller Calwich, further up the Dove. By 1318 the canons of Rocester claimed that cattle plague and bad harvests had reduced them to such poverty that they were obliged to go out and seek alms 'like beggars'.

In the mid-fourteenth century, the communal life of the canons seems to have been rather troubled. The abbot complained at the General Chapter of the Order that one of

JCB have turned part of Tutbury Mill (the old cotton mill at Rocester) into an academy for 540 pupils wishing to pursue a career in engineering and manufacturing.

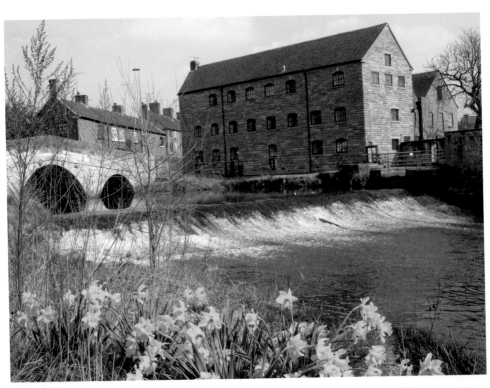

The prominent corn mill on the banks of the River Churnet has been converted into the offices of JCB Finance Limited.

St Michael's 700-year-old, 20-foot-high church cross is said to be the finest in the county.

his canons, sent to the King's court on business, 'had neglected his work and, contrary to his obedience, was wandering about spending much of the abbey's money and retaining its documents'. In 1377 the community (including the abbot) numbered six, five in 1381, seven in 1524, and at the time of the dissolution in 1538 there were nine.

St Michael's Church
Although the abbey had its own chapel, the present church, St Michael's, was founded in the thirteenth century for the villagers. However, St Michael's was entirely rebuilt between 1870 and 1972 by Ewan Christian, except for the thirteenth-century tower.

The Romans in Rocester
Adjacent to the church is the old vicarage which lies on an old Roman fort. The Romans chose Rocester to build a protective fort midway between Derby and Newcastle-under-Lyme at the end of the first century.

Excavations were carried out recently by Birmingham University and these support the theory that Rocester was probably the most important township of the area at that time with a population of about 1,000 made up of the military personnel at the wooden barracks and supporting civilians. The Roman Army left at the end of the second century and the fort was dismantled. But the civilians remained and Rocester continued as a busy trading centre throughout Anglo-Saxon times and the middle ages.

The embankment and hedge of the parish graveyard mark the edge of Rocester's Roman fort.

There is evidence of occupation in Rocester even before the Romans arrived. A decorated Bronze Age pot has been found in the locality and aerial photos show barrows to the south of the town. It is also believed that a small Iron Age hill fort once stood on Barrow Hill, just to the north.

The Limestone Way

Rocester is also the start of the Limestone Way. This 80-km trail (originally opened as a Matlock to Castleton configuration) now leads all the way up from its starting point close to Tutbury Mill in Rocester as far as Castleton in north-west Derbyshire, covering the majority of the landscape of the White Peak.

The first part winds up through the Dove Valley, passing through the Doveleys to Lower Ellastone and then west of Mayfield towards Thorpe, where it crosses over the Dove into Derbyshire at Coldwall Bridge, before heading on towards Tissington.

This early part of the Limestone Way, some of it along the banks of the Dove and much of it through the surrounding hills, is an excellent way to enjoy the beautiful countryside of these still rural lower regions of the Dove Valley.

Chapter 10
Towards Tutbury Castle

Heading south, the Dove winds away from Rocester and through countryside. The river is dissected now by busy A-roads carrying huge volumes of traffic past once-quiet agricultural settlements, some of which date back to Anglo-Saxon times. Passing east of Uttoxeter, she passes under the busy A50 on the new concrete Dove Bridge, right next to the old medieval bridge which used to carry the main traffic between Derby and Newcastle-under-Lyme.

Doveridge's entry in the Domesday Book (as 'Dubbige') denotes a settlement here firmly established before the arrival of William the Conqueror. When William arrived some of the Anglo-Saxon nobles, who accepted him as king, were allowed to keep their

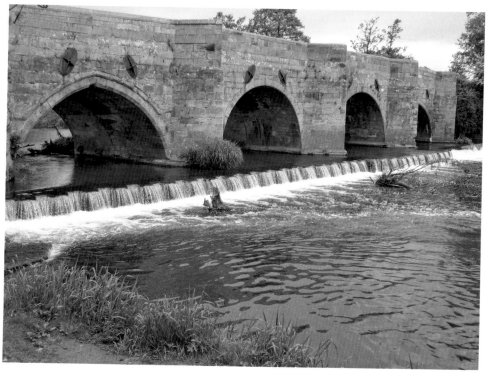

The fine late medieval bridge from which the village of Doveridge gained its name.

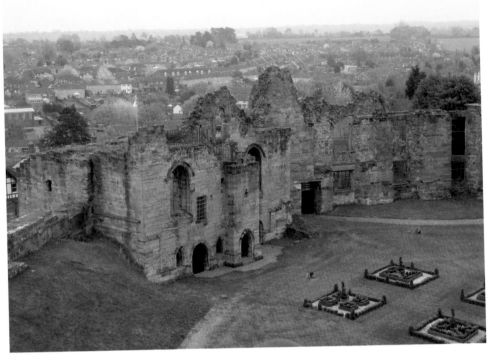

Tutbury Castle was one of the great centres of power in Medieval England.

lands, but after a rebellion in 1068–69 William established firm control of the Midlands and the North. He granted much of the land to his followers. He first granted Tutbury, at the southern end of the Dove, to Hugh d'Avranches, who built the castle there. The ruins remain with their commanding views across the Dove Valley to the Derbyshire hills which made this a natural defensive position.

But when Hugh was made Earl of Chester in 1071, some of his lands, including Tutbury, were given to Henry, Lord of Ferrieres and Chambrai in Normandy. The name became de Ferrers in English and the family held Tutbury for nearly 200 years, many streets and schools in the area still carrying the name. Henry de Ferrers had lands in many parts of England, but the 'lordship' or 'honour' of Tutbury was his most important estate and covered areas in both Staffordshire and Derbyshire. The de Ferrers family also established a priory in Tutbury, part of which still survives in the modern parish church.

This chapter follows the course of the Dove as she winds towards Tutbury, one of the greatest centres of power in medieval England. It calls off at the ancient settlements of Doveridge and Sudbury, a little further down the Dove, just two of the two hundred manors which fell into the hands of Henry de Ferrers. Fortunately, the bypasses diverting traffic away from their centres have helped to preserve the antiquity, peace and tranquility of both, leaving the hearts of these ancient settlements largely intact. Both villages once had grandiose halls built on the banks of the Dove commanding fine views across the river, but only one remains.

Above left: The west door of St Mary's Priory church in Tutbury was part of the priory of the mid-1100s.

Above right: Did Robin Hood get married under this tree in St Cuthbert's churchyard? We will probably never know for certain, but the tree has certainly witnessed centuries of village life in Doveridge.

Doveridge

Doveridge today is perhaps best known for a tree. For legend has it that under the vast boughs of the ancient yew tree in St Cuthbert's churchyard, Robin Hood (who was born in the neighbouring hamlet of Loxley on the outskirts of Uttoxeter) married his beloved. A ballad entitled 'The Pedigree, Education and Marriage of Robin Hood with Clorinda Queen of the Tutbury Feast' tells of Clorinda's meeting with Robin. She apparently killed a buck, which so impressed Robin he proposed on the spot. His ardour was further fuelled when, on the journey to Tutbury, she played her part in defeating eight yeomen who attempted to steal the buck.

> I am King of fiddlers and swear it is the truth,
> and call him that doubts it a gull.
> For I saw them a fighting and fiddled the while,
> and Clorinda sang 'Hey, Berry down'.
> The bumpkins are beaten, put up thy sword Bob,
> and now let's dance into town.
> Before we came in we heard a strange shouting,
> and all that were in looked madly,

The older part of Doveridge contains some interesting and characterful old buildings, including this Tudor house (dated mid-1500s) in Lower Street, thatched seventeenth-century cottages and the nineteenth-century manor house in Pickley's Lane.

and some were a black bull, some dancing a morrice,
and some singing Arther a Bradley.
And there we saw Thomas our justice's clerk,
and Mary, to whom he was kind,
and Tom rode before her and calle'd Mary madam,
and kissed full sweetly behind.
And so may your worship – But we went to dinner
With Thomas and Mary and Nan.
They all drank a health to Clorinda and told her Bold Robin was a fine man.
When dinner was ended, Sir Roger, the parson of Dubbridge (Doveridge), was sent
 for in haste.
He brought his mass book and bid them take hands, and he joined them in marriage
 full fast.
And then as Bold Robin and his sweet bride, went hand in hand to the sweet bower,
The birds sung with pleasure in merry Sherwood, and it was a most joyful hour.[11]

Whether the legend is true will probably never be known, but the tree continues to
flourish despite being estimated at over 1,400 years old, albeit supported by props and
girdled by chains.

St Cuthbert's Church
The church itself is included in the village's entry in the Domesday Book and parts of
the present church have been dated back to *c.* 1075. St Cuthbert is an Anglo-Saxon

The suspension bridge, built to divert the 'peasants' away from Doveridge Hall.

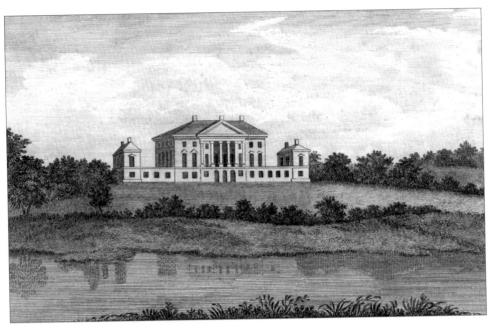

Doveridge Hall *c.* 1912. (DCHQ200376. Courtesy of Miss Frances Webb and www.picturethepast.org.uk)

saint, the cult of Cuthbert reaching its height in the eleventh century. But after the Norman Conquest the manor of Doveridge, along with many villages and estates, became part of the de Ferrers appendage and formed part of an endowment made by Henry de Ferrers to the priory of Tutbury when it was formed in about 1087. The church itself thus fell under the control of the monks of Tutbury.

Doveridge (formerly known as Dovebridge) was apparently much valued as it provided the priory with 34 per cent of its total income, which included the payment of tolls by traffic passing over the Dove bridge.

Another Doveridge Bridge

Further south and closer to the village there is an unusual suspension bridge over the river approached from a path near the church. This bridge was built by a Mr Frank Addison Brace, who leased Doveridge Hall from 1891.

Doveridge Hall

Doveridge Hall was built by Sir Henry Cavendish in 1769 and, just like Sudbury Hall a few kilometres downstream, it commanded superb views across the river. The Cavendish family (better known as Baron Waterpark) were lords of the manor in Doveridge for almost 400 years and their influence is still very much in evidence in the name of the local pub and among the marble effigies and tablets in the church which remember prominent individuals who have supported the village. The hall was used by the family until the 1890s when they decided to rent it out as a way of obtaining a more substantial income.

Frank Addison Brace leased it from 1891 but became annoyed by the 'peasants' who walked on the footpath close by. He spent £6,000 in building the suspension

The golden ball which crowns the small dome on the roof of Sudbury Hall acts as a beacon for travellers.

The gardens and meadows behind the hall sweep down to a lake providing a pleasant haven for both visitors and waterfowl.

Above: The Vernon Arms, an old coaching inn built in 1671, dominates the main road and provides a pleasant setting for outdoor as well as indoor eating.

Left: This eastern window was donated by Queen Victoria and Prince Albert in memory of the brother of the then rector George Edward Anson.

This window was donated on behalf of all the children who were evacuated to Sudbury from Manchester at the start of the Second World War.

bridge and diverting the footpath away from the hall – a high price to pay for increased privacy! Sadly, in later years the hall fell into disrepair and was finally demolished in 1938–39, but the footbridge still remains.

Sudbury Hall

Unlike Doveridge Hall, the impressive Sudbury Hall, a few kilometres further down the Dove, remains – dominating the surrounding landscape. This hall was built by George Vernon in the second half of the seventeenth century. The Vernon family were lords of the manor here from 1513, when Sir John Vernon married into the Montgomery family, who had held the manor since the Norman Conquest. The red-brick Sudbury Hall was eventually handed over to the National Trust by the tenth Lord Vernon, in 1967, who restored it and opened it up to the public in 1972.

The interior of the building is well worth viewing, containing many fine rooms and a great white carved staircase. The Long Gallery (which at 138 feet is twice the length of a cricket wicket) and the Main Hall featured as interior shots for Darcy's Derbyshire stately home Pemberley in the BBC's 1995 production of *Pride and Prejudice*.

Adjoining the hall, and popular with visiting groups of schoolchildren, is the Museum of Childhood which contains a reconstructed Victorian schoolroom and an old nursery with toys and games.

Left and below: Commanding views from the north tower of Tutbury Castle.

Sudbury Village

The heart of Sudbury has been preserved by the modern bypass constructed in 1972, which sweeps past Sudbury Open Prison. Home to about 500 category D inmates and around 200 staff, this modern construction just down the road seems a million miles away from the tranquility of the former estate village. Driving down the long lane past the Hall, to Sudbury's main street with its idyllically located bowling green and terraced estate workers' cottages, is like stepping back in time.

The village was rebuilt by George Vernon in the 1670s to harmonise with his newly built hall. Despite the proximity of the A50 (Derby to Stoke dual carriageway), the village still retains much of the serenity it must have enjoyed in the seventeenth century.

Amenities which are vanishing from other villages are still very much part of Sudbury. The village school built in 1831 is still in use. The fourth Lord Vernon, who had the school built, apparently declared that anyone who didn't send their children to school would not be allowed a cottage! The post office and village store is still the hub of village life. A butcher's shop and farm buildings which have become workshops for a blacksmith and a joiner all help to preserve the ambience and vitality of the village.

Next to the Hall, but quite difficult to find as it is largely hidden from view, stands All Saints Church. Although it was recorded in the Domesday Book, it has been extensively restored in later years. As well as some magnificent monuments to the Vernon family, the church contains some interesting windows.

The Vernon family influence was not restricted to Sudbury and its hall; 5 or 6 kilometres downstream of the Dove the dramatic outline of Tutbury Castle appears silhouetted against the skyline. The remains of this medieval castle would look considerably less dramatic, however, without the tower on top of the motte, which is, in fact, a folly added by the Vernon family to make the castle more picturesque when they leased it between 1660 and 1864.

The location is both enchanting, with its commanding views across the plain of the Dove Valley, and strategic. Its setting commands the crossing point of two key routes across the heart of England. It has been involved in a number of rebellions and civil wars, generally on the losing side, and so has been destroyed and rebuilt several times.

History of Tutbury Castle

Archaelogical evidence shows that the site occupied by Tutbury Castle has been in use since the Mesolithic period about 10,000 years ago. The Romans left evidence and so did the Anglo-Saxons, but the castle only enters the historical records a few years after the Norman Conquest. It is recorded in 1071 as one of the new castles built to stamp the authority of the Norman conquerors over the Midlands.

Successive generations of the de Ferrers family spent considerable sums on rebuilding the early earth and timber defences in stone. When the castle was besieged in 1153 by Henry of Anjou (who became Henry II the following year) it was described as 'of wondrous art ... impregnably fortified'.

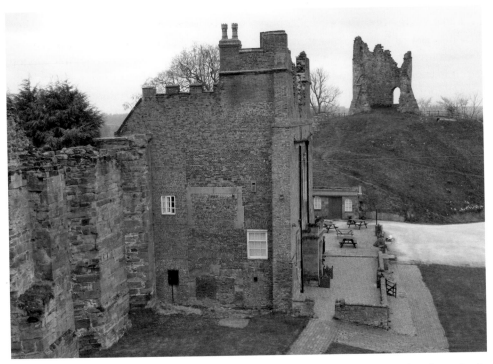

Lord Vernon of Sudbury built follies on top of the motte and the south tower of Tutbury Castle in the late eighteenth century.

In 1174 the castle was besieged again, when William de Ferrers supported Henry's sons, who rebelled against their father. When William surrendered, Henry ordered the castle to be destroyed, leaving little trace of the early castle to be found today.

The de Ferrers family came into favour with the Crown again and increased their wealth and power. But with Robert de Ferrers' rebellion against Henry III in the 1260s (discussed in the Hartington section of Chapter 4) the castle was besieged again, and Tutbury, like Hartington, was forfeited. Edmund Crouchback (the King's younger son and Earl of Lancaster) received many of de Ferrers' lands and Tutbury has remained part of the Lancaster Estates ever since.

Edmund of Lancaster and his son Thomas maintained the castle and spent money on various improvements to it. Thomas added a new tower over the gateway, a stable block, a new hall and an outer tower beyond the gate. But in 1322 the castle came under siege once more when Thomas led a party of nobles in a rebellion against his cousin Edward II.

The Battle of Burton Bridge

Both Thomas of Lancaster and Edward II gathered armies and headed towards Tutbury. Thomas headed for Burton, where he took a stand at the bridge over the River Trent. But Edward managed to fool Thomas by sending a small force to distract him. The rest of his army forded the river, and then attacked Thomas's army from behind. Taken by surprise, they were completely defeated and Thomas retreated to Tutbury.

Thomas didn't remain long in Tutbury. He fled to his lands in the north, so quickly that he was unable to take his treasury with him. Thomas was eventually hunted down and executed, and though the castle was not destroyed this time, considerable looting took place. Despite efforts to find it Thomas's treasury could not be found, although an enquiry established that three iron-bound barrels had been carried to the priory for safekeeping which contained a total of £1,500. These had disappeared without a trace.

The Tutbury Hoard

In June 1831 workmen made an astonishing find. Thousands of silver pennies (estimates suggest there may have been 300,000) were discovered in the bed of the River Dove. Before the authorities could move in to take control, thousands of the coins were sold off and only 1,489 remained to be properly recorded. The coins were claimed by the Duchy of Lancaster, who own the river bed, and treasure hunting in the river without consent is strictly illegal, even today. The latest recorded coin is dated 1321, which suggests that this must have been the missing hoard of Thomas of Lancaster. If the estimated total (before the coins were dispersed) is true, this makes the Tutbury hoard the largest hoard of treasure ever found in Britain.

The Minstrel's Fair

Thomas's lands were eventually recoverd by his younger brother Henry. His granddaughter, Blanche, married John of Gaunt (third son of Edward III), who eventually became Duke of Lancaster. John made many improvements to the castle, including building stone curtain walls in 1390. It was possibly John who also introduced the

The castle in its heyday.

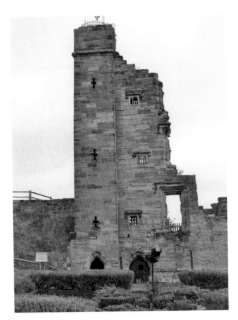

Above left: The north tower was completed between 1457 and 1460. Built by Henry IV's wife Margaret of Anjou, it later housed Mary Queen of Scots' priest and is said to be haunted by a 'white lady'.

Above right: Mary Queen of Scots (seen here in this 1797 image) despised Tutbury Castle. (DCHQ200205. Courtesy of Miss Frances Webb and www.picturethepast.org.uk)

'Minstrel's Fair' to the castle, a great festival of music which took place every year in Tutbury in August. The custom was interrupted in the seventeenth century, as it was feared that a gathering of so many people could spread the plague, but continued on a smaller scale until the end of the eighteenth century.

Henry IV, V and VI

When John of Gaunt died in 1399 Richard II took the opportunity to seize the inheritance belonging to his son Henry of Bolingbroke. (Richard II had frequently clashed with Henry and he had been banished.) But Henry returned to England and gathered support. Richard was deposed, thrown into prison and later murdered, and Henry became king as Henry IV. Since then the Duchy of Lancaster has always been held by the Crown, and Tutbury remains part of the Duchy today.

This was the period of Tutbury Castle's heyday when the House of Lancaster held the Crown. Major building work took place under Henry IV, then Henry V and Henry VI, including stone curtain walls around the inner bailey and towers (including one now lost on the north-west side).

The late 1400s saw the Wars of the Roses between the houses of Lancaster and York. Although Tutbury Castle was an obvious potential target, there is no record of it being attacked. But with the end of this period of warfare at the Battle of Bosworth in 1485, Tutbury had little military importance for a while.

The well in front of the castle is at least 120 feet (36.5 m) deep and has been covered with a decorative fountain to protect it from damage.

Mary Queen of Scots

Although the garden was improved under Henry VII, and Henry VIII visited in 1511, records from the 1500s suggest that the castle underwent a period of neglect and decay. In 1562 it was described as 'An old stately castle, decayed in many places, but … furnished with forests, parks and chases'. It was in this now rather inhospitable old building that Elizabeth I had Mary Queen of Scots imprisoned when the latter fled to England, mistakenly hoping that her cousin would restore her to the Scottish throne.

Mary was brought to Tutbury in 1569, but spent most of her captivity being moved from one place to another throughout the Midlands. She came to Tutbury three times between 1569 and 1571 and then again in 1585. On her early visits she was housed in reasonable comfort in the south range. But between 1571 and 1585 the castle deteriorated and Mary was lodged, for her final visit, in a building she described as a 'draughty old hunting lodge'. It was cold and damp, overshadowed by the castle wall and overwhelmed by the smell from the privies below. Mary hated it.

It was during her final visit that Mary became involved in a plot to help her escape and replace Elizabeth on the English throne. She had already been accused of spreading subversive messages through the designs of her embroidery. One of her surviving patterns is of a ginger cat – the colour of Elizabeth's hair – with a mouse in front of it. She often observed that she was like a mouse at the mercy of a cat (Elizabeth I) who was waiting to pounce. Elizabeth finally 'pounced' at Fotheringhay Castle in Northamptonshire, to which Mary was moved. She was executed there on 8 February 1586.

Although today's Great Hall dates from the 1630s, it is on the site of the medieval Great Hall. The decorations and furnishings on display are mainly from the Tudor and Stuart periods.

The Civil War

The castle underwent something of a revival in the mid-1630s. Charles I had the medieval range at the south end of the castle (which included the old Great Hall and Great Chamber) pulled down and replaced with a new red-brick building over 100 feet long.

When large windows were set into the outer wall (originally the old stone curtain wall) nobody expected the castle to be involved in a war again. But when tensions between the King and Parliament developed into war in 1642, Charles ordered the castle to be garrisoned. The large earth banks inside and outside the castle probably date from this time as earth banks absorb cannon fire.

The castle was besieged by Parliamentary forces in 1643, but a lack of supplies meant that the siege was quickly abandoned. The castle managed to remain in Royalist hands until 1646. During this time Charles I stayed at the castle twice, while travelling. But a Parliamentary garrison had been established a few miles away at Barton Blount to attack the castle's supply lines. When the castle was besieged again in March 1646 by Sir William Brereton, supplies were running out and there was sickness in the castle and town. The commanders of the garrison agreed terms of surrender with the Parliamentary forces. The following year, Parliament ordered 'that the castle of Tutbury be forthwith rendered untenable'. The people of the surrounding area began the process of destruction, carrying off stone and timber to be used for building elsewhere. Once enough damage had been done to render the castle indefensible, it was abandoned, leaving the ruins that we see today.

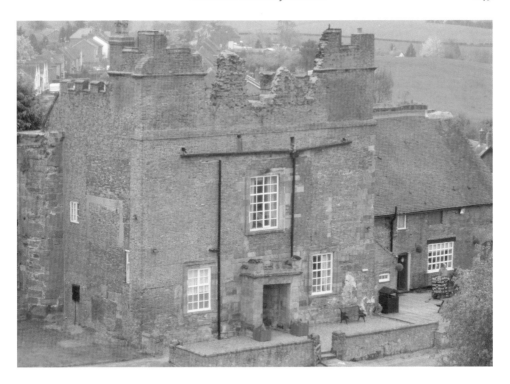

Above: The remaining brick house makes up almost half the original building.

Right: St Mary's priory church was left standing when the priory buildings were demolished.

Although some restoration work was carried out at the turn of the century, the series of six receding arches above the massive west door are original.

Tutbury Castle Today

When the monarchy was restored in 1660, the castle was partially restored and leased, as mentioned earlier, to the Vernon family of Sudbury until 1864. It became a working farm, and farm buildings (which have since become a kitchen and tea room) were added in the early nineteenth century. Public admission to the castle by ticket was introduced in 1847 and the castle continued to combine the roles of working farm and tourist attraction until 1952. The farm then closed and although the castle remained open to the public, little attempt was made to develop it as a tourist attraction until 2000.

It was then that curator Lesley Smith took over. Under her energetic direction the castle now plays host to a variety of historically based events throughout the year. These include re-enactments of periods in English history such as the Viking and Saxon period and the Boer War, colourful portrayals of characters from history including Mary Queen of Scots and Mistress Nell Gwynne (by the curator herself), as well as tournaments, ghost hunts, firework displays and more. You can even hire out the castle for a party or wedding.

Tutbury Priory

The first church on this site was probably Anglo-Saxon (or possibly even earlier). Work on the building that we see today was started in about 1086 by Henry de Ferrers, and was consecrated in 1089. About sixty years after the church was finished, Robert de

Detail of the beautiful carvings that surround the west door.

Ferrers established a priory here and staffed it with a prior and twelve Benedictine monks from Normandy.

The priory buildings covered about 3 acres on the north side of the present church, providing easy access to the waters of the River Dove. The de Ferrers family were generous benefactors to the priory, donating land, mills rents, fishing rights and the feudal service of peasants to name just a few. The priory grew quite rich with a lucrative income from tithes (medieval rates and taxes) and also tolls – including those for using bridges across the Dove.

But historical records reveal that the priory was not without problems. Following the Battle of Burton Bridge (1322), for example, the prior was accused of stealing large amounts of money, jewellery and other goods from the Castle: '7 cartloads of gold cloth, silver vessels and other ornaments to the value of £300; £40 worth of goods and a barrel of sturgeon'. He was fined £70, and later excommunicated for not paying tithes owed. In 1329 the monks were accused of 'bearing arms, hunting, general disorder and incontinence' (in other words being lacking in self-restraint, especially with regard to sexual appetite). Although the priory survived, by 1524 it was in considerable debt and the monks made numerous complaints about the prior's extravagance. The number of monks fell to four.

In 1538 Henry VIII dissolved the monasteries and the priory surrendered to the King's representatives. The prior received a pension and became the vicar while the priory buildings and monastic parts of the church were demolished. But the church, though much reduced, was left standing because it was the parish church in which the peasants worshipped.

Chapter 11

Journey's End

The Dove flows on away from the turbulent history of Tutbury Castle, past peaceful rural hamlets once owned by the monks at Tutbury Abbey, such as Marston on Dove on the Derbyshire bank. There is a thirteenth-century church here which is home to the oldest bell in Derbyshire. It was cast by John de Stafford at Leicester in 1366 and inscribed with the words 'Hail Mary'. The church of St Wilfred, around 5 km further down the Dove at Eggington, sold its bells. They were sold in 1553 to meet the cost of repairwork done four years earlier on the medieval Monks Bridge.

The bridge was maintained as well as built by the Burton monks, but following the dissolution of the monasteries the repair work fell on local inhabitants. It is recorded that two of Eggington's church bells had to be sold. Just beyond it, a twelve-arched aquaduct was built in 1770 by James Brindley for the Trent & Mersey Canal to cross over the River Dove, and in 1840 the Birmingham & Derby Junction Railway bridged the river. In 1926 Monks Bridge was bypassed by a new A38 road bridge, which now separates the old bridges from the village.

The Everys' Rock Tower still survives today, embedded in the river frontage of the current Rock House.

The dissolution and destruction of the religious houses impacted on the area in many ways. This is illustrated in some papers relating to this now peaceful village. The 'Every Papers' of July 1542 record an enquiry into five named individuals from Eggington who,

> with sticks, swords and knives assembled at Egynton and ... broke into the close of Thomas Rolleston of Egynton and riotously cut down and destroyed grain growing and committed other enormities ... against the King's peace.

This state of lawlenness prevailed throughout the area and whole country at this time.

The Battle of Eggington Heath

The village was at the heart of even more violent scenes a hundred years later during the Civil War. The largest battle to be fought in Derbyshire, known as the Battle of Eggington Heath, took place here as Royalists returned from battle at Newark, complacent from recent victory. They were taken by surprise by Parliamentary forces, who chased them through Eggington to the banks of the Dove and the Trent. Many were slaughtered, as their attempt to ford the rivers to escape their pursuers failed. Around 250 years later, a beautiful Cavalier sword was found in the thatched roof of an old local cottage that was being pulled down.

Sir Simon Every

The lord of the manor at that time, Simon Every, was on the Royalist side. Having become a magistrate for Derbyshire in 1636, he had been created a baronet by Charles I in 1641 for services to the King. When the Civil War began in 1642, Sir Simon was in charge of munitions and supplies for Tutbury and several other Royalist castles.

But he paid heavily for his support of the losing side. For the next two generations his family sought to avoid the Commissioners for Sequestrated Estates, eventually settling for a fine of £2,000 (now around £185,000).

Eggington Hall

In 1736 a terrible fire destroyed the Every family's Tudor hall. It was eventually rebuilt around 1780 by Sir Edward Every to a design by James Wyatt. Surrounding cottages made of wattle and daub were cleared to provide a 50-acre park and lake, and many of the new houses and farm buildings which we see today were built in brick. In 1902 King Edward VII and Queen Alexandra visited on their way to Doncaster Races. But only fifty-three years later the hall was a heap of rubble in a derelict park. This was due to a combination of factors, including a major flood in 1932 and the premature death of Edward Every, leaving his son an estate riddled with debt.

The Everys' Rock Tower

Eggington wasn't the only estate owned by the Every family. On the other side of the river they had also acquired by marriage the estate of Newton Solney. In 1758 they constructed a substantial folly-like tower on the banks of the river there, on the site

Memorial to Sir John de Solney in the parish church of St Mary the Virgin.

The Every family presence remains in monuments in the parish church, where they had a pew. This example is of Sir Henry.

Above left: The Every family presence remains in the name of one of the village pubs. The Unicorn is on the crest of the Every arms.

Above right and next page left: The Radcliffe family also contributed substantially to the restoration of the parish church of St Mary the Virgin, first built around the twelfth century.

of the former manor house, so that they could travel to Newton Solney by boat. Their jouney took them down the final kilometers of the Dove to her confluence with the River Trent, where 'Rock Tower', as it became known, still survives embedded in the frontage of the current Rock House.

Newton Solney

The Every family were lords of the manor at Newton Solney up until the end of the eighteenth century when Newton Solney was an agricultural village, much like any other.

They could trace their origins right back to the de Solney family who gave their name to the village. Alured de Solinia, a Norman knight, inherited Newton (as it was then known) in 1205. By 1300 it had become known as Newton Solney. It was the de Solneys who carved out the hunting park from the extensive woodland. The parkland to the west still makes up a large part of the village.

The de Solneys held the estate until 1390, when the last male de Solney died childless. However, the manor remained in the family through the female line, coming eventually to the Everys. But the Every domination of Newton Solney was not to last. When Sir Edward Every, eighth Baronet, died prematurely and unexpectedly in 1786, the estate

Above right: The village is rightly proud of both its history and its immaculate appearance.

was inherited by his nine-year-old son Henry, and the appalling debts owed by his father were quickly discovered.

Abraham Hoskins, an attorney and land speculator from Burton, was appointed as receiver of the estate in 1793. In May 1798, Hoskins' farm in Eggington was given to Sir Henry Every (who came of age the following month), while Hoskins awarded himself 103 acres in Newton Solney in return.

Abraham Hoskins

Abraham Hoskins made a huge impact on the village of Newton Solney. His parkland at the west end of the village and a number of buildings, large and small, both inside and outside the park, which were built by Hoskins and other members of the local gentry, give the village its unique character today.

In 1779, Hoskins built Bladon Castle (designed by Sir Geoffrey Wyatsville) on Bladon Hill, overlooking the village. Originally designed as a romantic folly (consisting of an impressive screen wall with a small banqueting or summer house at the back of it), the building was later converted to domestic use, possibly for Abraham Hoskins junior. Hoskins also built Newton Park House (the core of which became the present Newton Park Hotel) in the 1790s. This became his home and the heart of his estate.

But Hoskins' son, Abraham Hoskins junior, was extravagant. He was forced to sell the estate in 1876. He sold to Lord Chesterfield, who let Newton Park to William Worthington, the Burton brewer. After Worthington's death, it remained empty for a number of years before another brewer, Robert Ratcliff, acquired it in 1879 together with the majority of Hoskins' former property.

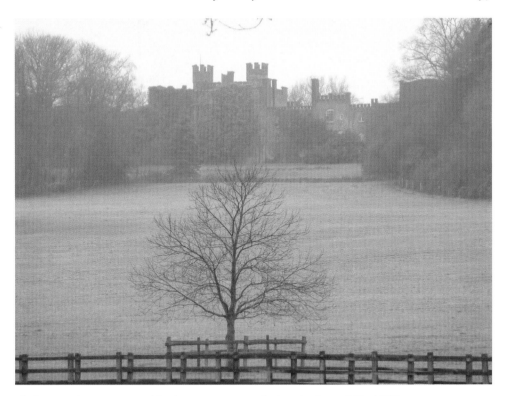

Bladon Castle was occupied by American troops during the Second World War.

The confluence of the River Dove with the Trent.

Robert Radcliffe

The Radcliffe family were generous benefactors to the village. Robert Radcliffe modernised Newton Park House. The original house had two and a half storeys and 5-foot by 4-foot bay windows. William Worthington had extended it while it was in his ownership and Radcliffe added a further two-storey projection to the front. The gardens were also revitalised and the property became one of the first country houses to be lit by electricity.

But on the death of Peter Ratcliff in 1955, Newton Park was sold once more. Most of the property in the village was bought by the tenants, and eleven years later Newton Park opened as a hotel.

Newton Solney Today

Under this succession of benefactors, the village of Newton Solney has flourished. The population of about 800 is higher than it has ever been and it remains an immaculate village. It is particularly attractive in the summer, when its pretty cottages, hanging baskets and tubs of flowers make it one of the most attractive villages in South Derbyshire. It comes as no surprise to discover that it has won several prizes in the Best Kept Village and Britain in Bloom contests. The Dove finally reaches the end of its spectacular course just behind and a little downstream from the Every's Rock Tower and the church of St Mary the Virgin.

Looking downstream from the point at which the two rivers join, it is not difficult to imagine the Anglian invaders who travelled up the Trent and formed this settlement here. The combined waters flow on silently now just as they did then. From here, like the waters of all Derbyshire's rivers, they will travel to the coast via the Humber Estuary, where they will be swallowed up by the daunting icy waters of the North Sea; only the salmon will return.

References

1. Izaak Walton and Charles Cotton, *The Compleat Angler, or The Contemplative Man's Recreation – Being a Discourse of Fish and Fishing*. All references in this book are taken from the version published by Coachwhip Publications in 2005.

2. George Gordon Byron, *Life, Letters and Journals of Lord Byron*. Edited by Thomas Moore. Published by J. Murray, 1839.

3. John Ruskin, *Fors Clavigera: Letters to the Workmen and Labourers of Great Britain*. 8 vols, 1871–84.

4. J. H. Ingram, *The River Trent*, 1985.

5. The *Monthly Magazine* of London began publication in 1796. It ran for forty-seven years and included contributions from Dr John Aiken, William Blake, Samuel Taylor Coleridge, George Dyer, and Charles Lamb.

6. Taken from *Bemrose's Guide to Derbyshire*, 1869.

7. James Croston, *On Foot Through the Peak*, 1862.

8. Sir Bernard Burke, *A Visitation of the Seats and Arms of the Noblemen and Gentlemen of Great Britain and Ireland*, 1855.

9. Letter dated 28th October, 1838 courtesy of Mappleton & Okeover website.

10. Quotation from 'Salmon go wild in the River Dove', 12 October 2009, http://www.environment-agency.gov.uk/news

11. Ballad contained in Alan Gibson, *A History of Doveridge*, 1996.

Further Reading

Ashbourne Guide & Souvenir, Landmark Publishing Ltd, 2010.

Bemrose's Guide to Derbyshire, Bemrose & Sons, 1869.

Browning, O., *Life of George Eliot*, BiblioBazaar, 2008.

Burke, Bernard, *A Visitation of the Seats and Arms of the Noblemen and Gentlemen of Great Britain and Ireland*, 1855.

Crichton Porteous, L., *The Ancient Customs of Derbyshire*, Derbyshire Countryside Ltd, 1985.

Croston, James, *On Foot Through the Peak*, E. J. Morten Publishers, 1862.

History of Ashbourne, Ashbourne Partnership and Ashbourne Heritage Society, 2010.

Fearnehough, H. W., *The Rivers of Derbyshire*, Derbyshire Heritage Series, 1990.

Gibson, Alan, *A History of Doveridge*, Churnet Valley Books, 1996.

Gibson. Alan, *A History of Rocester*, Churnet Valley Books. 2003.

Hislop, M., Kincey, M. and Williams, G., Tutbury: 'A Castle Firmly Built'. Archaeological and historical investigations at tutbury Castle, Staffordshire, BAR British Series 546, 2011

Porter, L., *Bygone Days in Dovedale and the Manifold Valley*, Ashbourne Editions, 1997.

Porter, L. , *Hartington & Longnor Guide & Souvenir*, Ashbourne Editions, 2010.

Smith, Michael E., *Castles and Manor Houses in and around Derbyshire*, 1992.

Williams, G., *Tutbury Castle Visitors' Guide*, Tutbury Castle, 2006.

Wall, B., *Sudbury History and Guide*, The History Press Ltd, 2004.

Websites

www.tutburycastle.com

www.derbyshireuk.net

www.peaklandheritage.org.ok

www.visitderbyshire.co.uk

www.peakdistrictonline.co.uk

www.peakdistrict.gov.uk

www.hollinsclough.org.uk

www.domesdaybook.co.uk

www.pricefineart.com

www.greatwalksinbritain.co.uk

www.ashbourne-town.com/villages/mappleton/index.htm